SYMBOLISM AND
ART NOUVEAU

Thames and Hudson · London

© 1975 Thames and Hudson Ltd, London

Text filmset by Keyspools Ltd, Golborne, Lancs.
Litho origination by Paramount Litho Ltd, Wickford, Essex
Printed in Great Britain by Cox and Wyman Ltd,
London, Fakenham and Reading

ISBN 0 500 41055 0

'There is some fascination to be derived from watching a change in artistic taste, or at any rate an artistic revival, taking place – so to speak – under one's very eyes. Hidden qualities are discovered in pictures hitherto despised or ignored; commercial pressures are applied by the dealers, and speculative buying begins "as an investment"; a cult that was once "camp" soon seems to be merely eccentric and then rather dashing; scholarly articles are written because there is nothing new to be said about established favourites; colour supplements spread the good news to a wider public. From some combination of these and other factors a new taste develops.' (Francis Haskell in *New York Review of Books*, July 1969.)

In the passage quoted above Mr Haskell, one of the best historians of artistic taste we have, was discussing French academic painting, but the point that he makes applies to an even greater extent to the subjects of this book. Ten years ago an inexpensive book directed at the broad mass of art lovers might have been written about Cubism, Surrealism or Impressionism, but never Symbolism or Art Nouveau. The last-named was considered to be the over-aesthetic last gasp of Victorian vulgarity, while Symbolism was not even well enough known to be dismissed. Clearly a huge shift of taste has taken place to allow this book to be published.

It can easily be forgotten by the person who is interested in art, visits exhibitions and reads books on the subject that the history of art is not absolute but fluid. Although there are independent-minded people who make their own expeditions into the past, most

take their lead from the historians who write the books and organize the exhibitions. The public may influence them by showing a preference for a certain type of art, in this case for a decorative and sensual one, but it will be the historians and the dealers who decide where the next revival is coming from.

Because historians very naturally want to make a name for themselves by rediscovering a new period, and dealers are interested in selling as many works as possible, a revival will usually lead to high claims being made for the art revived. This is certainly true of Symbolism; from being a forgotten or ridiculed style it has swiftly risen to being 'an alternative tradition of modern art', as Alan Bowness put it in the catalogue of the large exhibition which finally accorded Symbolism the accolade of historical re-spectability. Other writers, such as Philippe Jullian, go even further and place the Symbolists above the established masters of the birth of modernism.

The 'league of excellence' game is clearly not profitable in any terms of common sense. Art is not a competitive activity, and questions of promotion and relegation are hardly relevant to enjoyment. In the opinion of this writer certain artists are 'better' than others because they more consistently produce work of complexity and emotional depth, but one style is not necessarily any better than any other. It is natural that there has been a reaction against the somewhat clinical approach of the Cubists and other geometrical artists, and it is healthy that we should turn the searchlights of history into previously dim corners, as long as we retain some balance of judgment.

Revivals of past art usually mirror contemporary trends. Abstract Expressionism in the 1950s led to a revaluation of late Monet, and even Turner was hailed as a 'proto-Abstract Expressionist'! It is doubtful if the Art Nouveau revival of the mid-1960s would have occurred without Pop art, which rehabilitated exu-berant colour and linear decoration. In addition, Pop

4

frequently derived from artifacts of the past rather than from 'high art', and, as we shall see, the main impetus of Art Nouveau was in the field of applied rather than pure art. Minimal Art, so fashionable at the end of the 1960s, may have affected the revival of interest in the Neoclassicism of David; and the reaction against that Minimalism, a type of art too new to have been classified but which is often termed 'funky', is clearly related to the revival of Symbolism: both have an aesthetic of deliberate vulgarity.

One final factor must be considered in the revivals under consideration, and that is the influence of drugs. The last ten years have seen a remarkable increase of drug-taking, especially of mind-expanding drugs such as hashish and LSD, and particularly among the young. The qualities of the drugs have affected the popular art of today, the strip cartoons, the rock posters and underground magazines. Designers looking for a style that offered a visual equivalent to their drug-induced experiences found it in Art Nouveau and later in certain aspects of Symbolism. The connection of these styles to a world-wide movement unconnected with art led to a far wider dispersal of imagery than is common in most artistic revivals. The Art Nouveau style became, for a period, standard right across the Western world as a common language of the young. For once, control over our view of the past slipped out of the hands of the experts and dealers, and in this particular area they have not entirely regained it.

As a result of this, and also because of the speed of the revival, Symbolism, and to a lesser extent Art Nouveau, are still disputed territory. Against the claims of their defenders, there are many experts who dismiss certain of the painters illustrated here as artistically absurd; but at present it is enough to describe their work and the conditions in which it developed. If this introduction indulges in an occasional value judgment, then the reader must check it

against the work for himself and make up his own mind.

Although Symbolism and Art Nouveau are directly related, they are not the same thing. Indeed very few apologists agree on which artists can be included under either heading. There is a school of thought that says that only French artists of the 1880s and 1890s can properly be called 'Symbolist', and another that excludes the English Arts and Crafts movement from any discussion of Art Nouveau. Such art historical nit-picking is a fruitless activity. Generic names given to movements such as Symbolism, Cubism and so on usually appear after the movement is well under way and are often no more than a convenient form of labelling. Common sense and the use of the eyes show that in the last two decades of the nineteenth century and the first of the twentieth there were common ideas and visual styles circulating in Europe and America. These styles were united only in their opposition to the main currents of art at the time: academicism and Impressionism. To understand Symbolism and Art Nouveau, we must therefore go back in time and see how these two influences affected them. The two streams had their origins in two painters: Ingres and Delacroix.

In Ingres we see for the first time the emergence of public eroticism, which was to find its apotheosis in some Symbolist art. The paintings were 'ideal', and thus catered to the view that high art should raise human aspirations to a lofty plane; but their subject matter was not the noble life of the Romans, as with David, but more often than not naked women. The settings were usually exotic, frequently Middle Eastern, which made them respectable and remote, but the technique was so realistic as to make the smooth-skinned, soft-eyed beauties who inhabited them easily available for fantasy. The new public, the emergent bourgeoisie, in accepting Ingres had found the perfect method for eating their cake and having it,

for deriving erotic satisfaction from the most respectable high art.

Delacroix, on the other hand, was not interested in how the mind ought to conceive reality. He was far more interested in the eye. With Delacroix we find for the first time the idea that the eye can act independently of the mind, and that art can trace the actual process of seeing. He was the first painter to examine the play of light across objects in terms of its constituent parts. Instead of mixing colours on the palette, he put down a far wider range of colours separately on to the canvas and let the eye mix them there. He also began the process of excluding black and grey as means to depict shadow, using complementary colours instead: for the shadow of a red object, he would introduce green, and so on. Compared to later painters such as Seurat, his approach was still largely instinctive, but he was beginning the process of formulating theories of how light and colour actually work.

From these two sources two ways of thinking about painting emerged and as the century progressed gradually grew further and further apart. By the 1850s the opposition of the two schools was quite clear. The style based on Ingres had become the established 'official' art of the day, seen in the huge Salons and much sought after by the rich patrons of the time, while the line of development from Delacroix had gone underground.

That these two streams of artistic development should have diverged to such a degree in terms of public context is something that is difficult to understand from the twentieth-century viewpoint. It seems obvious to us that the academic art of the nineteenth century had little if any merit, and that Impressionism, deriving from Delacroix through Courbet, was the natural line of artistic development; and it seems extraordinary that paintings by Monet or Renoir should have been met with savage hostility when we

appreciate them for their charm and understatement. But savaged they were, and to understand why will help considerably in placing movements such as Symbolism and Art Nouveau in perspective.

Academic art takes as its canons of judgment the ideals of the past. It is a static concept which holds that the summit of artistic achievement has already been conquered and that new art must be judged by its adherence to already established principles. Reference should not be to the real world but to the history of culture, which is seen as being unaffected by the trivialities of everyday life. The Impressionists were seen as devaluing the status of art by negating this reference to the culture of the past.

It is, though, an ironic truth that the moment when art claims to be 'above' contemporary life is always the moment it becomes controlled by it. A man could exploit his workers to make a personal fortune and then spend it on 'high art' which made no reference to the reality of his and their situation. The combination of cultural respectability and high prices made the Salon virtually impregnable.

The Impressionists took as their criteria not those of culture but of its great rival, science. The Impressionists were painters of this new technological age: Monet painting steam from railway engines, Degas making use of the camera, Renoir depicting the emergent middle class at play; but the last thing the beneficiaries of this new materialism wanted was to be reminded of it. They required culture.

It was not only the subject matter of the Impressionists that made them unacceptable, but also their methods. They used their eyes like cameras and noted down what they perceived. This neutral method of working led to a discovery that science was not to reach until the early years of the present century, and which was in no way acceptable to the contemporary 'art patron'. This was that light, and by implication everything else, was a continuous pheno-

menon. Light was seen to penetrate everything equally and continuously. Furthermore, as Monet demonstrated in front of Rheims Cathedral, it was not static. Form itself changed with the change of light.

To deal with this observation, a new style of painting was necessary. If the eye shows that forms are not separate from each other in reality, a technique such as the smooth realism of academicism will be of no use. Thus through the middle and end of the nineteenth century we can observe the atomization of the brushstroke, which gets smaller and more regular until this approach reaches its logical conclusion in the dots of pure unmixed colour which make up the paintings of Georges Seurat.

For Seurat, science was all. 'They see poetry in what I have done. No, I apply my methods and that is all there is to it,' he said; and no more rigorous statement of the scientific method has ever been made by an artist. The Impressionists could rely on their eyes, but for Seurat this was too haphazard. Unfortunately, the eye cannot see the atomic structure of the world, so it is necessary to postulate a theory. So Seurat in his moment of complete scientific neutrality found himself taking art straight back into the realms of 'idea'. Only his particular sensibility enables him to steer the narrow path between what he observed and what he suspected he observed; and with his premature death the stream of art that had started with Delacroix and led through the Impressionists ran into a serious impasse which it could in no way have avoided.

The problem for those Symbolist artists, such as Gauguin, who approached their take-off point along the runway of Impressionism, was to find a new subject matter without losing the lessons learned along the way. The Impressionists had shown that a precise observation of nature led to what is now known as a 'field theory', the idea that all things are part of the field of observation of the observer and

carry equal weight within it. Furthermore, the observer himself is part of this field. The Impressionists had not drawn this last conclusion because they were committed to the idea of the impartial observer; but the implication lurked in their work. The years from 1880 to 1910 were to see the first attempt to deal with this implication.

Aware that to continue neutral observation of nature could only lead to the pure scientism of Seurat, Symbolist painters turned in the only direction available to them, inwards. The problem was how to depict the world of the subconscious, of the archetype, without falling into an academic rendering of myth. The answer as we shall see was to retain the external world as subject matter, but to paint in a way that reflected not what the dispassionate eye saw but what the observer felt. If one accepts that the observer and the observed are part of the same whole, then it becomes possible to describe one through the other. The feelings of the artist could be shown by a reworking of observed reality.

This idea was both difficult to grasp and a huge step in a new direction. Even in the work of hallucinatory painters such as Goya, we feel we are being shown something that was as real to the artist as everyday life, not a deliberate attempt to describe internal feelings and states of consciousness by recreating the external world to mirror the internal. It is not surprising that few if any of Gauguin's followers were able to understand this point, and that, to begin with at any rate, his influence was principally stylistic.

The first entirely successful painting in the new 1 style, Gauguin's *Vision after the Sermon*, is very much concerned with problems of symbolic landscape and the relationship between the observer and the observed. A group of Breton women have heard a sermon on the text of Jacob wrestling with the Angel, and after the service apparently participate in a

communal vision. The problem for Gauguin was how to show the nature of this vision. He could hardly show it naturalistically because visions are not natural phenomena, so an Impressionist technique would not do. Equally, an academic technique would be too clear-cut and idealized to express the strong emotions involved.

Given the state of confusion in thinking about the question of showing the internal world at that time, Gauguin's solution is astonishingly precise and complete. Instead of painting a 'real' landscape, he paints an emotional one. The figures of Jacob and the Angel inhabit a flat red ground of considerable spatial ambiguity. The bright colour not only has strong emotional associations but also pushes the figures forward, contradicting their size, so that it becomes impossible to say exactly where they are. The tree leaning across the picture strengthens this effect by seeming to grow out of the picture plane into the space in front of the surface. The women grouped along the bottom of the painting have the effect of cutting the viewer off from the action, making it clear that it is their vision that is being depicted and that it is their state of mind that governs the emotional landscape. If one looks at the women carefully, it will be seen that very few are looking directly at the wrestling figures; in fact most appear to have their eyes closed and to be directing their attention to a spot some distance to the left of the apparition. This underlines the point that the figures are part of their state of mind rather than independently observed, and indeed the whole painting has a unity about it which implies that it is impossible to separate the painting into subject and object, observer and observed.

Gauguin was the first artist to attempt to live like his art. The Impressionists were typical bourgeois Frenchmen who did not seek to be involved in scandal or to live differently from the general public;

the academicians were of course successful members of high society. Gauguin, on the other hand, after he had come to the point of view that his art could be about his life, realized that this inexorably meant that his life had to be about his art. He therefore, and at times his actions seem oddly deliberate, set about creating a character for himself, Gauguin the painter, the martyr, the iconoclast, the wild man of the avant-garde. It was a role he relished.

It is in this determination not to separate art and life that we can see the clearest connection between Gauguin and other Symbolist painters of quite different styles. A glance through the illustrations of this book will show that we are not considering a style but an attitude of mind, which affected artists of differing training and aesthetic intention. Painters brought up in the academic tradition also faced a dilemma, albeit a less sophisticated one than that faced by followers of Impressionism. The academic style had by the 1870s run out of the little steam that it ever had, and the classical subject matter was seen to hold no more surprises. Painters who did not wish to enter the matter-of-fact world of the Impressionists, and who also lacked the vision and courage of a Gauguin, were forced to look further afield for images which would still have some power and mystery. They were helped in this by the rising interest in the occult, typified by the exotic speculations of Eliphas Levi, and in Eastern thought, made fashionable by the arrival in society of Madame Blavatsky. As one might expect it was the cruder and more spectacular elements that appealed to most of the artists. These interests coincided with a fashion for drug-taking, usually laudanum or hashish, based upon the experiments of Baudelaire and Gautier some years earlier.

It was an easy and attractive method of escaping the triviality of everyday technological life. Gauguin, who used his own mind for his source material,

needed only to 'become himself' to fulfil his role; the occultists, not quite capable of comprehending the subtlety of Gauguin's role and unable to find a ready-made occult society to live in, had to create one of their own. The result was the Salon de la Rose + Croix, headed by one of the most preposterous figures in the history of art, the self-styled Sâr Peladan.

Peladan would be a familiar enough figure today, guru of a small band of beaded and bearded followers publishing incomprehensible underground maga- zines. But in the Paris of the 1880s, already reeling under the onslaught of Wagner and anxious for any- thing that would break the stifling monotony of life, he was hailed, by some, as a saviour. His books, including an erotic novel of almost total obscurity entitled *Le Vice suprême*, were avidly read, and young painters and writers flocked to him. He was exactly what they needed, a man with a complete system that did away with the boring business of having to find their own. All you had to do was wear robes, take part in the odd minor rite and paint the most cryptic and sensational pictures you could.

However the Salon de la Rose + Croix was not entirely ridiculous, in spite of its leader. The idea on which its art was based had already attracted many painters of talent, Gauguin included, and in the field of literature Stéphane Mallarmé, Paul Verlaine and, a lesser figure, J. K. Huysmans. The idea was that the function of art is not to define the obvious but to evoke the indefinable. The feeling that art should concern itself with ideas rather than with everyday life, but with ideas that had a basis in the human imagination rather than in the moribund dreams of the academy, was to be the strongest single impulse in the art of the period: and its consequences have conditioned much of the 'difficulty' of twentieth- century art.

Clearly, the methods of Gauguin were too private and those of Peladan too exotic to appeal to the public

at large, so the time was soon ripe for a more widely-based style to emerge which would allow the art-loving public to feel that it could be involved without having to change its way of life. It follows from this that the new style would not be of painting or sculpture but of applied art, so that the public could incorporate the idea into its life-style. The relationship between a man and the picture he owns is essentially a static one which requires time and patience to enter. How much more satisfactory then actually to *use* the work of art, whether in the form of printed material, books, china, or glass. And so because many Symbolists were concerned less with problems of picture-making than with evolving a life-style, it was logical that the next development should be concerned with the application of art to life. In this sense Art Nouveau was both the natural child of Symbolism, in that it continued the earlier movement's preoccupation with style, and a reaction against it, in that it shifted the emphasis from the private to the public world.

Gauguin and Symbolism

Writers on Symbolism, faced with the daunting prospect of giving shape to such a many-sided movement, are prone to the invention of massive similes. Philippe Jullian, the movement's principal apologist, has described it as a walk through a huge forest, with each glade and path representing a different aspect of the movement, or, more convincingly, as a visit to a museum, with various groups of rooms opening off each other. My suggestion is that one might think about it as a huge and somewhat exotic railway station. The lines converge towards it from all parts of the art landscape, some of them terminating here, while others pass through towards stations further down the line called Expressionism, Abstraction and Surrealism. The two stations of Symbolism and Art

Nouveau are separate but so close as to be virtually joined. Each platform is subtly different from the next. The Gauguin platform is flooded with sunlight, but not very crowded; the Rose + Croix platform is in deep shadow and the seats on the train are covered in red velvet, alchemical brews are offered in the buffet car and the price of the tickets is your good taste. A few passengers are changing to this train from the one standing on the academic platform, where everybody seems to wear top hats and the Légion d'Honneur, although neither train ever seems to go any great distance. Between them, the Pre-Raphaelite train is pulling in from England, with an Arts and Crafts coach, booked through to Art Nouveau, stuck on the end. At the extreme northern edge of the station Munch sits gloomily by himself waiting for Strindberg, who, as usual, is late.

Whatever metaphor one uses, the important thing is that it should contain the idea of many separate and diverse strands if not coming together, than at least running parallel for a period of time. Only in this way will one avoid the problem of having to reconcile Symbolism's many different styles or to chart a central course through its tangled lines of development.

In describing the movement's artists and their interrelationships one can start almost anywhere; but the work of Gauguin is as good a place to begin as any, although it postdates some of the other work illustrated here; his was clearly the most consistent and subtle mind to be affected by the Symbolist idea.

In 1883 Gauguin had given up his job as a bank clerk to become a full-time artist, a decision that led eventually to the break-up of his marriage two years later. He had been a Sunday painter until then, using the Impressionist style to which he had been introduced by his friend Camille Pissarro. Once he had made his decision, his commitment to art was total, and he soon began to find that Impressionism was not

a style that could easily contain such a full-blooded approach. It was not until 1888, after a visit to Martinique which had given him a taste for bright colour, that he found the solution to his problem. Aware that the painting of everyday life was too tame an undertaking for a man of his voracious appetite for experience, and unwilling to enter the moribund world of classical myth that was practised in the Academy, Gauguin deliberately turned his back on 'civilization' and set out to find the most primitive area of France. For artists to look to the primitive is now such a commonplace idea that it is easy to forget how radical it was at that time. The Pre-Raphaelites in England had turned to the past for inspiration, but because they found it more exquisitely beautiful than the present. Gauguin was not interested in beauty as much as power. He needed to find some culture where ideas were still felt emotionally rather than played with intellectually, and he found it in Brittany, a part of France that still retained a sense of Celtic otherness.

In Pont-Aven, on the Brittany coast, Gauguin found a temporary haven. He took with him the young painter Emile Bernard, who had originally suggested that he look in that part of France for his answer. Between them they evolved a new style of painting, which they called Synthesism. A few years later, after the two painters had quarrelled (throughout his life Gauguin was quite incapable of retaining friends for longer than two or three years), Bernard insisted that it was he that had been the first to paint in the new style and that Gauguin had merely copied him. But whoever was the first to execute the first painting, there is little doubt that it was Gauguin who
1 provided the theoretical basis. Compared to *The Vision*
2 *after the Sermon*, Bernard's Brittany paintings are decorative but unsophisticated. He grasped the visual essentials of the new style, but its aesthetic and philosophical implications were beyond him. Nevertheless,

Gauguin obviously benefited from the younger painter's presence. He enjoyed the cut and thrust of argument and was always open to new ideas. It was this urge to test his theories against other painters whom he admired that led him to Vincent van Gogh, with ultimately tragic results. It is an indication of the accuracy of Gauguin's eye that he, almost alone, understood the value of what Van Gogh was doing.

The two wrote to each other frequently, Gauguin expounding his theories with relish and exuberance and Van Gogh painfully trying to explain his more personal methods. He was aware that he might be susceptible to Gauguin's more powerful personality, and on one occasion let himself be persuaded to paint a picture from his imagination rather than from life. It was the nearest Van Gogh got to Symbolism, and he quickly rejected it. Although the Dutch painter's work has in common the use of 'real' landscape distorted to reflect the emotions of the painter, it lacked the other essential ingredient of Symbolism: the existence of an independent Idea. Van Gogh's paintings are always direct descriptions, while Gauguin's employ the idea of symbolic reference to something other than the ostensible subject.

This can be seen in the portrait Gauguin painted of himself to send to Van Gogh, which is inscribed *Les Misérables*, a reference to Victor Hugo's novel of an alienated man pursued relentlessly by society. Gauguin's attitude to painting and to himself as a painter is revealed in a letter written to Bernard describing the work:

'I believe it is one of my best efforts, so abstract as to be totally incomprehensible. . . . First the head of a brigand, a Jean Valjean [the hero of *Les Misérables*], personifying a disreputable Impressionist painter likewise burdened forever with the chains of the world. The drawing is altogether peculiar, being complete abstraction. The eyes, the mouth, the nose are like flowers on a Persian carpet, thus personifying

4

17

the symbolic side. The colour is remote from nature, imagine a confused collection of pottery all twisted by the furnace! All the reds and violets streaked by flames, like a furnace burning fiercely, radiating from the eyes, the seat of the painter's mental struggles. The whole on a chrome background sprinkled with childish nosegays. Chamber of a pure young girl. The Impressionist is such a one, not yet sullied by the filthy kiss of the Académie des Beaux-Arts.'

Gauguin referred to himself as an Impressionist because, although he was reacting against Impressionism, there was still no word to describe his style. None of the Impressionists themselves would have accepted such a romantic and alienated description of the painter's role. The description is also illuminating in showing how Gauguin thought about symbols. Colours and visual emblems are used for their associative value rather than as direct reference. Not many of us nowadays would associate the background wallpaper with the 'chamber of a pure young girl', but we would accept that it does have a certain innocence about it. Gauguin was wise enough not to ram the symbols down our throats by making them too specific, and it is this psychological subtlety that raises him above most other practitioners of Symbolism.

As one might expect, a man of such force of personality and novelty of thought had a considerable effect on those painters who were drawn to him. These included Bernard, Maurice Denis, Paul Sérusier and Charles Filiger, all of whom passed through a 'Breton' period. Denis and Bernard were attracted by the simple way of life in Brittany, and, using it as subject matter, managed to simplify their own paintings. They took as their method Gauguin's use of flat colour, and at times seem to venture further into the area of decorative abstraction than their master. But neither painter managed to incorporate the philosophical content that was the basis of much of Gauguin's art. Where he succeeded in capturing some

of the intensity of the religious feeling native to that part of France, they could only show the colourful patterns of Breton life.

7 Filiger, on the other hand, was more successful in portraying the piety of the peasants. Intensely religious himself, suffering from guilt about his homosexuality, he found it far easier than his more sophisticated friends. But where they lacked Gauguin's psychological insight, Filiger lacked his aesthetic boldness. Rather than invent a new method of painting, Filiger preferred to refurbish the old ones. In this he bears some similarity to the Pre-Raphaelites, in that he also returned to pre-Renaissance sources for inspiration, in his case to Giotto and the Sienese.

Gauguin's most direct disciple was Paul Sérusier, who was a theorist and writer as well as a painter. Sérusier's career shows that he was highly susceptible to influences and picked up theories like blotting paper. His writings are thus more important than his paintings, with one odd exception. This is a work

5 called *The Talisman*, painted on a cigar-box and glowing with rich colour. It was executed in curious circumstances, with Gauguin standing literally at the painter's right hand telling what to do. 'What colour is that tree?' Gauguin would ask. 'Yellow,' replied Sérusier. 'Then put down yellow.' So Sérusier would apply yellow straight from the tube. The result of this practical lesson he took back with him to Paris and showed to all his friends, slightly uncertain whether he was showing them a work by himself or Gauguin. There seems to be no doubt that Sérusier actually painted the picture, but as he never again achieved anything near its quality, the credit for the work should really go to Gauguin, and is another indication of the extraordinary power of the man.

With Gauguin's departure, his followers, as one might expect, were left in disarray. Some stayed on in Brittany and were forgotten, others returned to Paris to find other umbrellas to shelter under, the

Nabi movement being the principal of these. This was a theoretically high-minded ('Nabi' means priest in Hebrew) but loose grouping of artists including Maurice Denis, Sérusier, Pierre Bonnard, Edouard Vuillard and Paul Ranson, and as one might expect of such an aesthetically diverse body, never produced a style unique to itself. The carefully observed bourgeois interiors of Vuillard have little to do with paintings such as *April* by Maurice Denis.

8 *April* is an interesting work because it shows how a painter like Denis, whose sympathies, where subject matter was concerned, were with the main body of the Symbolists but who had learned too much from Gauguin to use their methods, embarked on a path that led towards Art Nouveau. The strongest part of the painting is the organization of the various arabesques that curve across the surface, from the path to the vegetation in the foreground. Denis has attempted to counter this fluidity with a straight fence drawn half way up the painting, but the effect is awkward. The emotional content of the work is no more than a suggestion of mood. The next generation

6 followed illustrators and designers such as Eugène Grasset in retaining the decorative flow of line while rejecting the Symbolist content.

Before we finally leave Brittany for the more civilized decadence of Paris, one curious work

10 demands attention. This is *Our Lady of Penmarc'h* by Lévy-Dhurmer, an artist who painted in various Symbolist styles. The almost *faux-naïf* placing of the figures, and the disturbing degree of realism he brings to the faces, make it a work that could have been painted at any time in the last hundred years, and yet is quite unlike anything else. That a minor painter can produce one work of such startling freshness of vision is perhaps indicative of the character of Symbolism; like its successor, Surrealism, it created the sort of cultural climate where such flowers could be encouraged to bloom. The same cannot be said for

any of the more systematic approaches to art. Lévy-Dhurmer was able to experiment in many different Symbolist styles, bringing to each an eclectic professionalism. His decorative panels of marsh-birds show a quite different approach to paint from the Breton picture, the shimmering veils of colour reminding one of Whistler or even late Monet. If Wagner was the principal musical inspiration of Symbolism, this work corresponds to Scriabin's chromatic landscapes.

Meanwhile Gauguin himself was pursuing his quest for the primitive to its logical conclusion. In 1891, just as his stylistic innovations were beginning to be absorbed and imitated on a wider scale, he left France for the South Seas. He had understood the central problem of Symbolism, which was that it was impossible to infuse a painting with mystery and archetypal meaning if you are carrying around in your luggage the traditions of French nineteenth-century painting, or, as a later poet put it, 'You cannot light a match on a crumbling wall,' and in spite of the time he had spent in Brittany he still felt hemmed in by civilization.

When he finally reached Tahiti, Gauguin found that Western colonial civilization had already destroyed most of the old culture of the islands, and that the ease of living he had anticipated was not to be found. It was only the role he had taken upon himself that kept him going and enabled him to paint the paradise which he had expected to find, and which, as he now realized, existed only in his imagination.

His method of painting remained essentially the same as it had been in Brittany. The painting *Manao Tupapau* is typical of the period. The title means 'Thinking of the Spirit of the Dead', and it shows a ghostly figure appearing to a young girl. In his description of the work Gauguin makes it clear that the apparition is in the imagination of the girl and not a literal event.

21

Having made this point, he continues: 'She rests on a bed which is draped with a blue pareu and a cloth of chrome yellow. The reddish violet background is strewn with flowers resembling electric sparks and a rather strange figure stands beside the bed. As the pareu plays such an important part in a native woman's life, I use it as the bottom sheet. The cloth has to be yellow both because this colour comes as a surprise to the viewer and because it creates an illusion of a scene lit by a lamp, thus rendering it unnecessary to simulate lamplight. The background must seem a little frightening, for which reason the perfect colour is violet. Thus the musical part of the picture is complete.'

Gauguin's use of the word 'musical' is interesting. Poets such as Verlaine and Mallarmé had pushed literature towards music, because they saw that only by liberating it from the normal use of words could they make it truly symbolic of a state of mind. Most of the Symbolist painters, as we shall see, did not manage an equivalent liberation of visual language. Gauguin on the other hand realized that by freeing colour and form from their descriptive roles he could achieve a result very similar to Symbolist verse. Instead of being pictures *of* symbols, the pictures *were* symbols.

Gauguin's life in Tahiti went from bad to worse. He lived in a state of poverty, and by the mid-1890s had contracted syphilis. His quarrels with the other French residents had left him in near isolation, so he moved to a more primitive island, Papeete, but found things no better there. He even considered returning to France, but his friends there warned that it was the exoticism of his subject matter that was bringing him the occasional sale, and that a move to France would dry up even that meagre market. In 1897 he attempted suicide, but, as always in practical affairs, failed.

Just before his attempt on his life, he painted his largest painting, which he saw as his testament.
11 Entitled *Where do we come from? What are we?*

22

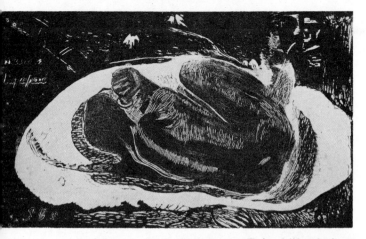

Paul Gauguin (1848–1903). *Manao Tupapau (She Thinks of the Ghost)*, c. 1892. Wood engraving, 8 × 14½ (20.3 × 36.2).

Where are we going?, the work is the masterpiece of Symbolism, if the movement is considered from any sort of broad perspective. It is designed to be read from right to left, starting with the two women in the bottom right-hand corner, representing pure joy in living, moving through the man picking fruit (the Tree of Knowledge) to the idol representing man's pursuit of the unknown. All stages of human life are shown, from the baby to the old man. The symbolism of the work is not overt, as Gauguin had long known that to make a symbol too obvious rendered it impotent, and so the painting can be considered on many levels. It is a pessimistic work in that it offers no easy answer to the questions it asks, and optimistic in its rich colour and form. One might say that, just as Gauguin had anticipated twentieth-century field theory in his earlier work, here he demonstrated the point that Wittgenstein was to reach forty years later, that the question *is* the answer, that the way the

23

painting is realized is the solution to the problem posed.

Gauguin was almost alone in his time in so successfully marrying content and form. In this he was untypical of Symbolism, and nowadays it is the discordance between the two elements that we recognize as being the most consistent aspect of the style. Yet although Gauguin is isolated by his genius, he had much in common with many other painters in the movement. We have seen how he had a strong effect on the artists grouped round him in Brittany, but it is also true that some painters had an influence on him. Chief among these was Puvis de Chavannes.

Puvis is probably the least sympathetic of the Symbolists to our modern tastes. The uniform greyness of his compositions, the deliberate lack of excitement and the unending classically draped maidens (if anyone ever painted 'maidens' rather than girls, it was Puvis) make it difficult for us to understand the revered position he held in the eyes of many painters of the time. Artists as diverse as Gauguin, Seurat and Aristide Maillol paid homage to him, and the Nabis adopted him as their godfather.

But it is in the neutrality of the works, the very factor which makes them difficult to appreciate, that Puvis's claim to fame lies. We are accustomed in these days of Minimal art to an aesthetic of neutrality, and Hard Edge painting has demonstrated the effect of treating all parts of the canvas with the same level of intensity. In the 1870s, when Puvis arrived at his mature style, such an aesthetic was revolutionary. Academic painting was usually concerned with the attempted highlighting of a single moment, and dramatic lighting would usually be employed, rather as in a certain brand of Hollywood epic. The Impressionists had been led to an 'all-over' aesthetic where each part of a painting carried equal weight, but their discoveries could not be applied to anything other than a small easel painting: they depended too much

on the painter being able to set down his canvas in front of the subject.

Puvis was not interested in imitating nature; his concern was with large-scale decorative schemes. His solution was to use large essentially flat areas of equal colour. This enabled him to create a general mood rather than to illustrate a specific moment. Thus almost all Puvis's paintings show figures in a state of rest or minimal movement. St Genevieve, subject of a large decorative scheme for the Panthéon, is seen standing on a balcony looking out over the city of Paris, of which she is the patron saint. Where other painters might have shown an incident in the life of the saint, Puvis shows the broader aspect of her relationship with the city. One might call it abstract figurative painting.

Occasionally Puvis would attempt a more emotionally charged scene as in *The Poor Fisherman*, a painting much admired by Seurat who adopted its tonality in many of his works. It makes no concessions whatever to the pleasure principle: the tonality is uniformly grey, and there is no story for us to grasp. Yet the painting is a disturbing one. J. K. Huysmans, a frequent defender of Symbolism, wrote: 'It is dry, hard, and as usual, of an affected naive stiffness. I shrug my shoulders in front of this canvas, annoyed by this travesty of biblical grandeur achieved by sacrificing colour to line. But despite this disgust which wells up in me when I stand in front of the painting, I cannot help being drawn to it when I am away from it.'

One can sympathize with Huysmans' predicament. There is an awkwardness to the painting that makes it strangely affecting. The sloping lines of the shore and mast have the disconcerting affect of making the whole landscape seem unstable and menacing, while the flat solidity of the paint surface brings it forward to add a touch of claustrophobia. The figures seem to be both immovable and in states of awkward im-

balance. It seems to be a very general painting, in that no specific event is taking place, yet the girl in the background is clearly in motion. All in all it is one of the most disturbing paintings to come out of a movement whose intent frequently was to disturb, but the effect is brought off without the paraphernalia that characterizes so much Symbolist work.

Like his paintings, the influence of Puvis was general rather than specific. One can see it in Seurat, who lies outside the scope of this book; in Gauguin, who borrowed Puvis's use of flat paint, although with a more ambitious palette; in Maurice Denis, whose *April* uses figures of girls dressed in white as a method of ordering the composition, a device surely learnt from Puvis. In the Swiss painter Ferdinand Hodler one can detect an influence in the rather flat use of paint in large decorative schemes. Hodler was known both for figure compositions, which are often strongly reminiscent of Puvis, and for paintings of mountains. The Alps of course had long been a favourite subject of painters, but they were usually treated dramatically, with thin shafts of sunlight spotlighting the mountains. Hodler used a more neutral technique, and tended to give equal weight to all parts of the painting. The result is light and airy, but without focus. As a result one realizes that the subject of the painting is not the light effects in the mountains, as it usually was with other painters, but the mountains themselves. The very neutrality of the treatment imbues the subject with a metaphysical quality.

Moreau and Redon

In complete antithesis to Puvis, the other great father figure of Symbolism, Gustave Moreau, plunged into rich and vibrant colour. His career had started in the orthodox fashion, in the Salon, where he was known for paintings such as *Oedipus and the Sphinx*,

which combined Ingres' style of painting figures with a tonality not far removed from Puvis. Like Puvis, Moreau wished to break away from the anecdotal aspect of academicism, and so he tended to show his figures at the moment of confrontation rather than action. In *Hercules and the Hydra of Lerna*, the hero is shown facing the monster across a sea of bodies prior to battle. The result is a tense stillness rare in academic painting. But the preparatory sketch for the painting shows that Moreau's interests were elsewhere. Already the paint is beginning to break up, and it is becoming difficult to tell where one element stops and another starts.

In 1870, when his official career seemed set for success, Moreau withdrew from public exhibition. 'He is a hermit who knows the train timetables,' said Degas, somewhat cattily, and it is true that Moreau kept himself fully informed of all new developments in painting. His open-mindedness made him the best teacher in Paris, and painters as ultimately diverse as Henri Matisse, Albert Marquet and Georges Rouault studied with him, all excepting him from their contempt for art teaching at the time.

During the period of his absence from the Salon, Moreau concentrated on watercolours and oil sketches. Like Gauguin, he realized the necessity for a new visual language, and in many ways his solution was even more startling than Gauguin's and still remains controversial today. Instead of a flat and systematic use of colour for composition, Moreau began to investigate the paint surface itself. He was a great admirer of Baudelaire and Mallarmé, and wished to find a method of painting equivalent to their rich and evocative use of metaphor. His painting style became looser, the pigment being laid on thickly and allowed to create accidents of colour. One could say with some justification that Moreau discovered the principles of Abstract Expressionism, and that by the end of his life he was painting what he called 'colour

studies' that rival the best works by Willem De Kooning and Franz Kline, albeit on a far smaller scale.

When he returned to showing his work in public, the change was obvious. Where before the paint had been smooth and the details impeccably painted, now the surface was thick and crusted with colour, brush-marks clearly visible. The paintings caused a sensation, but surprisingly were not vilified like those of the Impressionists, whose style was often more restrained. The public could see that Moreau's work was still Art by its subject matter: *Jacob Wrestling with the Angel*, *David Meditating*, and, endlessly, *Salome*. Salome had become, both for Moreau and for writers such as Mallarmé and Huysmans, the central symbol of the age. Evil and innocent at the same time, exotic and sensual, alluring but dangerous, she exemplified the Symbolist view of women, a view which had become a literary cliché in Romantic poetry. Moreau returned to the subject again and again, showing her dancing before Herod almost naked in a dimly lit temple.

17

In 1886 Huysmans used Moreau's paintings of Salome to set the scene for his novel *A Rebours*. His hero, a tedious aesthete named Des Esseintes, surrounds himself with 'evocative works of art which would transport him to some unfamiliar world, point out the way to new possibilities and shake up his nervous system by means of erudite fancies, complicated nightmares and suave and sinister visions'. Pride of place in his collection of works by Moreau, Redon and Rodolphe Bresdin goes to Moreau's *Salome*. Huysmans devotes considerable space to a decription of this work, and the following should give a flavour of his style:

'With a withdrawn, solemn, almost august expression on her face she begins the lascivious dance which is to rouse the aged Herod's dormant senses; her breasts rise and fall, the nipples hardening at the touch of her whirling necklaces, the strings of

diamonds glitter against her moist flesh; her bracelets, her belts, her rings all spit out fiery sparks; and across her triumphal robe, sewn with pearls and patterned with silver, spangled with gold, the jewelled cuirass of which every chain is a precious stone, seems to be ablaze with little snakes of fire, swarming over the matt flesh, over the tea-rose skin, like gorgeous insects with dazzling shards, mottled with carmine, spotted with pale yellow, speckled with steel blue, striped with peacock green.'

This passage, and the use to which Huysmans puts such paintings in his book, gives an idea of the essentially literary interpretation of art common in Symbolist circles. Although Huysmans captures some of the richness of the painting, he adds too many of his own theories and prejudices to be an accurate critic, and his discovery of erotic nightmares in the *Salome* seems to me ridiculous. Moreau's paintings, however much they may try to locate the sub-conscious levels of myth – and it is doubtful if the painter thought that way at all – remain essentially charming and innocent. His figures evoke characters from a medieval romance rather than chimaeras from the realms of sleep, and the all-over use of colour in continuous arabesques piled one on top of each other implies a positive energy-filled world rather than the negative and decadent end of a culture that Huysmans describes.

18 Moreau's work remains paradoxical, and in the final analysis, compared to artists such as Gauguin, unsatisfactory. The figures of nubile young girls Moreau was so fond of never quite fit into the almost abstract background; it is as if he had discovered the tool of abstraction and then did not know what to do with it. His instincts as a painter were those of an Impressionist, but his aspirations as a man of culture were towards the Salon and the by then empty pool of myth. At his best, as in the *Salome* paintings, the two parts of his art came together to produce works

of startling beauty. But his art is a useful touchstone; through it we can see how painters such as Gauguin achieved a new synthesis which was beyond Moreau, but we can also see how much closer he got to a satisfactory solution than many of the painters of the Salon de la Rose + Croix.

The other Symbolist artist with a claim to greatness was Odilon Redon. Like Moreau, he was something of a recluse, and although he was lionized by younger painters after Gauguin's departure for Tahiti had left the movement bereft of a hero, he always remained independent. His vision was too private and personal to have any significant influence.

Redon was one of those fortunate men who make the right connections at the right time. At the moment when he decided to devote his life to art he met two men who were to have a profound influence on him. These were a botanist, Clavand, whose particular speciality was microscopic work, and Rodolphe Bresdin, an important precursor of Symbolism in general. Bresdin was a master printmaker in both engraving and lithography, whose entire *oeuvre* is in black and white. It is indicative of his influence on the younger artist that Redon did not touch colour for the first twenty years of his working life. Bresdin's work combined an eye for the strange with a meticulous approach to detail, and this influence, coupled with the even more curious sights he saw down Clavand's microscope, started Redon on his course as an imaginative artist.

Redon's *oeuvre* can be divided into two parts: the early black and white works in the form either of drawings or lithographs, and the later work using colour. For many years it was by the later work that he was chiefly known, while recently the tendency has been to consider the earlier work more important. The coloured paintings are often extremely beautiful, reminiscent in their loose paint and treatment of
20 figures of the work of Moreau. Redon's *Pandora*

Rodolphe Bresdin (1825–85). *The Good Samaritan*, 1861.
Lithograph, $30\frac{5}{8} \times 24\frac{3}{4}$ (78 × 63).

shows the same free use of thick paint and rich colour coupled with a carefully drawn figure, although the nude is more classically derived than Moreau's medieval figures. The use of flowers is also typical of Redon's later work, underlining his continued interest in the natural world. The painting is charming and airy, but lacks the punch of his early work.

19 Perhaps the most interesting of Redon's paintings is the *Portrait of Gauguin*, done as a memorial (in 1904). The profile of the artist is idealized and given a sumptuous setting in which flower forms rest on a more abstract background. Redon had long been an admirer of Gauguin and had corresponded frequently with him. Why he chose this particular form for the portrait is made clearer by his own comment on Gauguin's work: 'Above all else I love his sumptuous, regal ceramics; it was here that he created truly new art forms. I always compare them to flowers discovered in a new place where every one seems to belong to a different species, leaving the artists who follow the task of categorizing these flowers into their respective families.' The portrait can then best be read as a portrait of Gauguin the ceramicist, and its glowing colours do remind one of the glazes on pottery.

But it is in his earlier black and white work that Redon's particular genius emerges. He seems to have had an open line to his subconscious, and his images entirely lack the literalism, the deliberate and rather forced perversity, of much Symbolist art. Flowers with faces, spiders with leering grins, skeletons that are somehow also trees; his subjects come directly from the world of dreams, and his masterly technique enables him to transfer them directly on to paper. Yet there is nothing uncontrolled about his work; the effect is deliberate and pre-conceived. Often a title is added which is like a small poem running parallel to the visual impact: *The eye floats towards infinity like some weird balloon*; *The*

breath of wind which supports human beings also inhabits the spheres; or His weak wings could not lift the animal in those black spaces. Like all Symbolist poetry, these titles are not easy to translate because the words are used for their evocative sound as much as for their meaning. The last mentioned reads in French: *L'aile impuissante n'éleva point la bête en ces noires espaces.*

Typical of his works in black and white is that entitled *The Marsh Flower, a Sad and Human Head.* As so often in Redon's work, the background is impenetrably dark. The head hanging from the plant seems to create its own light and illuminates only a small area. There is no explanation for the image, no literal meaning beyond the cryptic title. Mallarmé, who much admired the work, wrote to Redon about it: 'This head of a dream, this flower of the swamp, reveals with a clarity which it alone knows and which will never be talked about, all the tragic fallacies of ordinary existence. I love too your caption which, although created from a few words, correctly shows how far you penetrate into the heart of your subject.'

Huysmans included work by Redon in the same context as work by Moreau; and yet significantly, while he was able to write the purplest of passages about Moreau's work, he found that Redon's works would not really yield to verbal description. They are too self-contained and purely visual, and as such not typical of much Symbolist work.

The Rose + Croix painters

Gauguin, Moreau and Redon are all manifestly artists of originality and quality, and like all great artists they pursued their own visions even when it led them into isolation. The main body of Symbolist work was neither obviously good nor original painting, and tended to be executed to a formula. In the case of the artists discussed so far one feels that the

visual solution is inseparable from the aesthetic issues; while with most Symbolists one feels that the idea came first and the vision followed.

The most notorious of Symbolist groups, the Salon de la Rose + Croix, took as their bible the works of Edgar Allan Poe. Poe said of poetry: 'Its sole arbiter is Taste. With the Intellect or with the Conscience, it has only collateral relations. Unless incidentally, it has no concern whatever either with Duty or with Truth.' When Poe refers to Taste he does not necessarily mean the word in terms of good or bad taste: the meaning is that a work of art should be judged by its aesthetic qualities (including its power to stimulate the imagination) rather than its moral content. The French Symbolists were much drawn to Poe's own subject matter, with its haunted castles and necrophiliac heroes; and, like Poe, they often showed woman as beautiful but corrupt, an immaculate and pure skin enclosing a fetid swamp.

To Poe were added Wagner, with his technique of building up passages of augmented sevenths until the nerves are at breaking point, Baudelaire, Mallarmé and Verlaine, who had begun to investigate these areas in poetry. In painting they drew largely on the academic styles, although artists such as Arnold Böcklin influenced their choice of subject matter. Böcklin's allegories of life and death were immensely popular, and there was a time when an engraving of his *Isle of the Dead* was as *de rigueur* in a fashionable house as a Hockney would be today. His subdued tonality and the classical quality of his figures were a little insipid for the painters of the Rose + Croix, who were aiming at headier brews, but there is little doubt that Böcklin prepared a good deal of the way.

The English Pre-Raphaelites also had their effect. We shall return to them later; at the moment it is sufficient to point out the similarity between the religious ecstasies depicted by Rossetti and the almost orgasmic self-absorption of many figures in French

Odilon Redon (1840–1916). *The Marsh Flower, a Sad and Human Head*, 1885. Charcoal on paper, $19\frac{1}{4} \times 13$ (49 × 33). Rijksmuseum Kröller-Müller, Otterlo.

Symbolist painting. On both sides of the Channel artists were trying to find methods of showing ideas rather than actual events.

Typical of the most extreme elements of the Rose + Croix is the work of Jean Delville, whose paintings usually have a strong Satanic element Delville had a phenomenal drawing technique and an imagination quite devoid of any of the usual restraints that an artist imposes on himself. His work often approaches the erotic with a determination that even the most liberated painters of today might balk at. A drawing, *The Idol of Perversity*, of an almost naked figure seen from about the height of the groin, is idealized in that the breasts have a tautness and fullness unobservable in reality and the lips are unbelievably full; it is a fantasy, and its modern equivalent in terms of style is Vargas, the American pin-up artist, although his creations are far cosier.

24 *Satan's Treasures*, a large oil painting, also shows Delville's skill in achieving a visual effect. The precision of the drawing is combined with a red so strong that it creates a vibration across the centre of the painting; it is like looking into a fire and half-seeing figures writhing inside it. The arabesque of Satan's wings, if that is what they are, is an effect as overstated as the quality of the red, and sweeps the eye into a disturbing vortex. It is impossible to look at the work without in some way being affected by it.

Writers on nineteenth-century art differ wildly in their opinions on the quality of paintings such as this. It is obvious that in terms of the central development of art over the last hundred years, this type of Symbolism is quite unrelated to the standards we normally use to judge art. We cannot say it is 'bad', as we might say that André Derain's later work was 'bad' compared to his earlier work, because the intentions of Symbolism are so different from those of the mainstream of modern art. Delville was not interested in making points about the objective nature

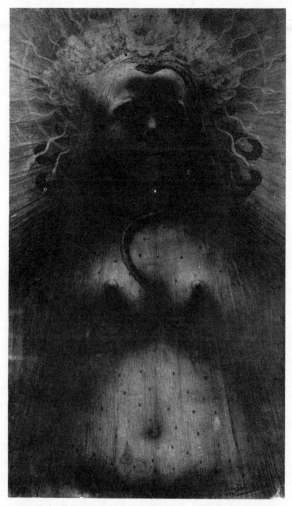

Jean Delville (1867–1953). *The Idol of Perversity*, 1891.
Drawing, $37\frac{3}{4} \times 22$ (98 × 56). Galleria del Levante, Munich.

of art; he wanted to arouse a strong reaction in the viewer. Our own reactions will, of course, be very different from those of the public of the 1890s, for we bring to the paintings an awareness and enjoyment of the discrepancy between intention and effect, which makes it even more difficult to make up our minds.

Many paintings of French Symbolism strike us as 25 absurd, or at least incongruous. Both Point's *The* 22 *Siren* and Séon's *The Chimaera's Despair* combine a sophisticated approach to colour and brushwork with a ridiculous central figure. In itself, Séon's painting is skilfully composed, with the strong vertical of the cliff giving a curiously unstable effect to the painting, while the cold colours create an intense emotional landscape. Unfortunately the figure of the Chimaera presents more difficult problems that Séon could not resolve. Poets of the time repeatedly referred to Chimaeras, but they could allow the unsettling poetry of the word itself to carry their medium. But the painter has to show what the poet has only to describe, and this desire to follow the poets into essentially literary fields was the undoing of many a Symbolist masterpiece. Séon's Chimaera seems to have strayed out of a literary tea party, and looks more as if she is complaining about the cucumber sandwiches than singing a universal song of archetypal despair.

But Symbolism was nothing if not ambitious, and the artists of the movement were continuously looking for that one stunning image, a metaphor that would 23 illuminate the human condition. Léon Frédéric's *The Lake – The Sleeping Water* comes very close to bringing off an unlikely effect. At first sight the image seems merely sentimental; but the more it is examined the more disturbing it becomes. The sleeping children are drawn with great accuracy of observation, and the swans really seem to be floating over them. The lack of central focus makes the painting seem specific and general at the same time.

Absolute self-confidence was a necessary aspect of the movement in its more public forms such as the Rose + Croix. The doubt and hesitation one finds so often in the work of really great artists had no place in such a deliberate assault on conventional life in the name of hidden truth. It was an inevitable part of the aesthetic of this area of Symbolism that the paintings should exhibit no trace of the self-searchings that appear in the work of Gauguin or even Moreau. This led to a quality which we might call 'synthetic', used in the sense that Miss World is a 'synthetic' rather than a real woman. The product must show no evidence of hard work or struggle; it must seem effortless and as if it arrived complete.

This aspect of Symbolism is at its clearest in the more religiously inclined painters. Satanism and perversity provided one kind of thrill for painters like Delville, but the sicklier aspects of Roman Catholicism offered images of equal emotional weight with the added benefit conferred on sales by respectable sentimentality. Carlos Schwabe was one artist associated with the Rose + Croix who made this area his speciality. His paintings were executed with meticulous regard to detail, and one can often detect the influence of the English Pre-Raphaelites in the early Renaissance quality of his work. His painting of detail is usually far superior to the over-all ordering of the work, as can be seen in the *Virgin of the Lilies*, where the lilies are beautifully observed and then used in a compositional device that looks more like a celestial escalator than anything else. The literalness of the image destroys it. The same can be said of his *Death and the Gravedigger*. The painting very nearly comes off; the use of vertically hanging branches of willow skilfully expresses the mood of the picture, the colour of the angel is finely judged, and the curve of her wings around the old man is an oddly touching idea. But then Schwabe has to show the reaction of the gravedigger, a real man suddenly confronted with an

unreal situation, and the picture breaks down. His reaction is too unsubtle, too much in the traditions of Grand Guignol to carry conviction, and now it is a different type of pleasure that takes over, pleasure in the discrepancy between the intention and the realization, a 'camp' pleasure. Such is the fate of many Symbolist paintings.

European Symbolism

Whether one can call painters such as the Belgian James Ensor and the Norwegian Edvard Munch Symbolists is debatable, but their work is part of the same impetus and climate that gave rise to Symbolism and shows the same use of dream-like images and distortions. Ensor, although his violent brushwork was entirely original, perhaps might not have found it so easy to draw on his own imagination had not Gauguin and Redon prepared the ground.

Ensor's vision of the world at times came close to the psychopathic. He combined a rich, almost sweet, range of colour, applied thickly, with images of alienation where all faces become masks and all roads lead to hell. His *Self-portrait with Masks* shows the artist hemmed in by a sea of grinning faces, his eyes the only ones which are not blankly void. When he painted entirely from his imagination he chose subjects like *The Fall of the Rebel Angels* and showed the hellfire as thick and almost liquid. 'No light but rather darkness visible', said Milton, describing his version of hell, an observation that Ensor would have well understood.

Ensor tackled his nightmare head-on; the other great northern painter of the period approached his vision more gradually, although when he reached it, it was, if anything, still more powerful. Munch had travelled to Paris first in 1885, where he had been much taken with Impressionist painting. The works

31

of his formative years show him trying to fit an Impressionist style to his horrific view of the world, not entirely successfully, and it is not surprising that on his return to Paris he was ready for the influence of Gauguin, a painter who could show him the way out of the matter-of-factness of Impressionism into the heightened world of symbols.

But Munch did not have Gauguin's iron control; the devils in his soul were too insistent to take easily to the French painter's systematic use of colour and brushstroke. His first great works look more like Van Gogh than Gauguin; perhaps he and Van Gogh had a northern spirit in common. *The Scream*, probably Munch's most expressive work of the period, has the Dutchman's fluid sky and landscape, but they are painted with an intensity and violence beyond even Van Gogh. Munch described the sensation that led to the painting:

'I was walking along a road with two friends. The sun set. I felt a tinge of melancholy. Suddenly the sky became blood red. I stopped and leaned against the railing, dead tired, and I looked at the flaming clouds that hung like blood and a sword over the blue-black fjord and the city. My friends walked on. I stood there trembling with fright. And I felt a loud unending scream piercing nature.'

The painting makes clear that it is nature that is screaming. The figure on the bridge holds his hands to his ears and his mouth is open, but any noise coming from it is drowned in the maelstrom around him. Van Gogh may have experienced emotion as powerfully, but he also, in his lucid moments, knew the burning glory of creation. When he was able to paint at all, he could balance these two factors and express himself through descriptions of the external world. As such he was not a Symbolist. Munch, on the other hand, had no relief from his apocalypse and was forced to find a method of generalizing his pain, in other words of creating symbols.

27

The experience of Gauguin led Munch to two discoveries. One was the woodcut, a medium that Gauguin frequently employed to great effect. And the other, stemming from the first, was the use of flat areas of colour. This enabled him to draw back from the total violence of works like *The Scream* into a more controlled expression of his vision. Where before all elements of the picture seemed to merge into each other in one wave of energy, now the figures stand out in isolation. The landscape still coils and flows, but the figures become almost inert, spectators of a power they cannot control or understand.

28

At times a peaceful, almost decorative quality can be seen. The colours and organic shapes at times remind one of Art Nouveau and of the many posters that the first decade of this century produced. After 1908, the year in which he suffered a complete collapse and was successfully treated, the work begins to lose some of its previous violence, although he often returned to his old woodcuts and experimented with new and strange colour combinations.

It is instructive to compare Munch with the French Symbolists, particularly those of the more ostentatiously decadent school. All used similar images: death, woman as vampire, madness, or ambiguous young girls; but none of the French painters seemed able to instil much real force into them. Munch on the other hand, because he had the courage to let his emotion dictate his techniques, was able to strike to the heart of the subject and release it in all its force. There is also the point that while many of the French painters might have felt a genuine sense of general cultural disintegration, few of them were able or willing to observe the process inside their own heads. Munch had no choice.

Other artists, who are usually considered separately from any account of Symbolism because their main contributions are outside that field, should be mentioned in passing. Because the movement was not

a stylistic one but a general state of mind that affected artists, musicians and writers, many painters and sculptors were influenced by some of the Symbolist ideas. Auguste Rodin, for instance, surely owes something to Symbolism in his more erotic works. The way the figures emerge from the 'background' of stone until they are precisely articulated reminds one of Moreau's or even Delville's figures. The smooth perfection of the skin of Rodin's nudes is the opposite of 'realistic' description, and the long curving lines of the bodies are reminiscent of Debussy or Verlaine. There is also a case for considering the Italian sculptor Medardo Rosso as a Symbolist. His works are often made of wax which seems to be melting in front of us. The route that led Rosso to this technique is surely the same as that which led Moreau to his disintegrating paint surface, with the same implication of a world of continuous flux.

Even Picasso, whose Cubist work was to put the final nail in the coffin of Symbolism, was affected by its ideas. In his Blue Period, the use of colour is distinctly emotional rather than descriptive or structural, and his method of working fairly similar to Gauguin's. His figures of that period are symbols of the human condition rather than portraits of real people. His etching *Saltimbanques* can be seen as his version of *Where do we come from? What are we? Where are we going?* since it is also a frieze of figures representing different stages of life arranged across a wide ground. Instead of Tahiti, Picasso substitutes the circus as his metaphor, but the intention and method is similar to Gauguin's.

In Italy the Symbolist style was softened and used for decorative purposes. The work of Segantini does not strive for the *coup de théâtre* as does so much French Symbolism; he still used the languid ladies so common in art of the period, but we are not asked to believe in them or to take them particularly seriously. The emphasis on the flowing line looks forward to

Pablo Picasso (1881–1973). *The Saltimbanques*, 1905. Dry-point, $11\frac{3}{8} \times 12\frac{7}{8}$ (28.9 × 32.7).

Art Nouveau and is not so far in feeling from the work of the Swiss artist Augusto Giacometti. Both are using the draped female form in essentially decorative 33 work; Giacometti's painting uses the flat areas of colour typical of Art Nouveau, while Segantini is still modelling form in space.

Symbolism, as it has been so far discussed, was very much a Continental phenomenon. Exoticism as a way of life never took root in Britain. When Symbolist ideas crossed the Channel they were pruned of their worst excesses and given a certain refinement. Even when the Aesthetic Movement was at its peak in the last two decades of the century, the best England could offer to compare with the decadent cavorting of the Salon de la Rose + Croix was Oscar Wilde and

his white lily. But, when one considers Wilde's fate at the hands of his fellow countrymen, it is perhaps not surprising that artists tended to restrain their less orthodox points of view.

In talking about Symbolism in terms of English art we are on dangerous ground: there are those who think that such a term should not be applied to any English painter. Nevertheless one can point to certain ideas held in common on both sides of the Channel, and it is interesting to note that although these ideas usually reached their ultimate development in France, they were often first conceived in England.

The best example of this is the work of the Pre-Raphaelite Brotherhood, a loose grouping of artists in many ways similar in intention to the later Salon de la Rose + Croix. Both groups were concerned with finding an alternative to the choice between academicism and naturalism, both groups tended to look into myth and fairy tale for their subject matter as well as showing an interest in religious themes. Both groups tended to use their subject matter to express a state of mind rather than to describe an event. Here, however, it becomes more difficult to draw comparisons because neither group was consistent within itself.

The Pre-Raphaelites can be divided into three camps. The first, historically speaking, consisted primarily of the leaders of the Pre-Raphaelite Brotherhood of 1848: Dante Gabriel Rossetti, John Everett Millais, William Holman Hunt and (not officially a member) Ford Madox Brown. Its aim was to cleanse art of the complicated and painterly qualities that had accrued since the Renaissance and to return to it a purity of vision based on the styles of the early Renaissance painters. Parallel to this was a younger group centring on William Morris, which included Edward Burne-Jones the painter and William de Morgan the ceramicist. Morris shared Rossetti's distaste for post-Renaissance art, but because his character drew him as much to social issues as to

aesthetic ones, he concentrated on the fields of decoration and applied art which he saw as a fundamental aspect of civilization. His influence in these fields was enormous.

The third group was more of a regrouping than a separate school, and consisted primarily of Rossetti and Burne-Jones. Rossetti had rejected the meticulous Pre-Raphaelite style proper, with its intensely observed detail, in favour of a more luminous and visionary type of painting which is at times reminiscent of certain aspects of French Symbolism. The painting of the Annunciation, *Ecce Ancilla Domini*, demonstrates this well. But where a painter such as Schwabe was interested in showing a general idea, Rossetti is interested in the psychology of the moment: we become involved in a way that never happens with the products of the Rose+Croix.

Rossetti was a mystic whose painting is a reflection of the interior world he experienced and attempted to transcribe. Like Redon, or Ensor, he projects a variety of experience which is entirely his own and which cannot be separated from the method he used to portray it.

Yet there is a bloodlessness in Rossetti's work, as if he could not face the true nature of his inspiration; at times this makes for a suppressed tension, almost sexual in nature. The figures in his painting seem uneasy in their bodies, as if the dualism between spirit and flesh were pulling them apart. Twenty years later the French painters were to have no such qualms, but their work only rarely attains the psychological vitality that Rossetti's best works show. The English have never been very good at dealing with the physical facts of life in their art, which perhaps explains the delicate awkwardness found in so much of Rossetti.

Burne-Jones, on the other hand, although he too had his vision, was a more earthbound character who had to work hard to bring his painting into line with

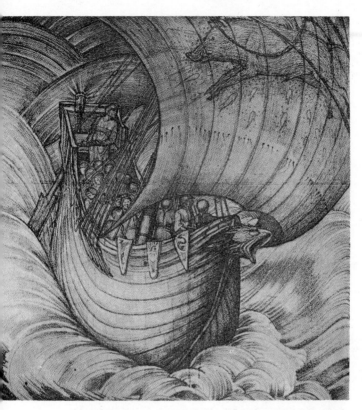

Sir Edward Burne-Jones (1833–98). *Voyage to Vinland the Good*, 1884. Black crayon, cartoon for stained glass, $30\frac{1}{4} \times 30\frac{3}{8}$ (76.9 × 77.2). Carlisle Museum and Art Gallery.

his imagination. He was also a craftsman, in a sense that Rossetti never claimed to be, and took great delight in experimenting with media such as stained glass, pottery, and book illustration. This professionalism, coupled with a wide knowledge of the history of art, made it difficult for him to find his own voice.

Like the French Symbolists, Burne-Jones turned to myth for his subject matter, but unlike them he was

not interested in exotic gods from the east or chimaeras from the murkier aspects of classical myth. His real subject matter took a long time to emerge, but when it did it was a very strange one: sleep. His two masterpieces, the *Briar Rose* series on the legend of the Sleeping Beauty, and *Arthur in Avalon*, both show the principal characters asleep, and many figures from other paintings have the look of somnambulists. Yet these sleeping figures are frequently surrounded by nature in excess and by richly ornamented objects and materials. World-weariness, a favourite theme of the French, had no place in Burne-Jones's scheme; the feeling is rather of immanence – that something will happen rather than that something has happened. The clarity of observation he inherited from the founder members of the Brotherhood, with its resultant three-dimensional depiction of objects and plants, adds to the sense of beginning and is quite opposite to the sense of dissolution and decay that pervades so much French Symbolism. One has the feeling that the French painters saw themselves as the end of art, the final hectic rhapsody before brute civilization finally takes over, and their works often have an 'end of the world' feeling about them. Burne-Jones's work has none of that sense of doom; perhaps he would have considered it extravagant.

Art Nouveau

The English have never approved of excess, particularly of the gloomy variety; and so it was perhaps inevitable that Art Nouveau, which was partly a reaction against the more portentous elements of Symbolism, should have originated in England with the Arts and Crafts Movement. This was principally inspired by William Morris, who like the other Pre-Raphaelites had been attracted to medieval art. Unlike them, however, he was not content merely to paint pictures influenced by such art; his social

concerns led him to a position where he could consider the re-creation of the best aspects of medieval society in the present. One of the fundamental parts of this vision concerned the role of the artist. Morris did not see the artist as an individual standing aloof from society, but as someone emerging naturally from it. He considered that the moment that art lost its decorative and functional basis and became independent of other disciplines, it lost its central purpose of enriching society and became the plaything of rich patrons.

Accordingly Morris concentrated on reviving the idea of applied art. His own speciality was fabric and wallpaper design, but he also acted as a focal point for many other craftsmen and artists. He knew the work of A. H. Mackmurdo and his disciple C. A. Voysey, which ran parallel to his own, although neither artist could be said to be directly under his influence.

The achievement of this group of designers was radically to rethink the concept of pattern. Before Morris, fabric design had tended to be three-dimensional and illusionistic in character. Large bunches of cabbage roses would be drawn with some perspective and shading, an effect that tended to be fussy and negate the inescapable two-dimensionality of a floor or a wall. Morris flattened out the design, removing any attempt to show flowers or birds realistically. The emphasis was switched from the subject matter to colour and line of great richness and complexity.

For inspiration Morris looked at any part of the history of art that struck him as useful, to medieval tapestry, to Jacobean hangings and to Oriental design. This eclectic method was picked up by those around him: for instance, William de Morgan, the group's ceramicist, studied Islamic and Hispano-Moresque pottery and as a result rediscovered lustre techniques that had been largely forgotten.

By the 1880s a growing body of connoisseurs was buying the products of the Arts and Crafts Movement.

Fashionable houses were entirely papered and hung with Morris designs, and pots by De Morgan and paintings by Burne-Jones would be bought to complete the whole. Even Pre-Raphaelite styles of dress were copied as the idea of living aesthetically caught on. Because the art was applied, it needed to be used to fulfil its role, and this enabled non-artists to take part in the movement. The same process can be seen in the emergence of Pop styles in the mid-1960s.

This way of looking at art as part of the fabric of living meant that artists could apply themselves to a wide choice of media. Where before an artist was someone who painted pictures or made sculpture, now he could design wallpaper, make pottery or illustrate books. This enabled artists such as Aubrey Beardsley to find their true role.

42 Beardsley was a graphic artist who needed to work on a small scale. His technique of combining large areas of flat colour with fine line work was perfectly suited for printing techniques, with the result that his images were widely disseminated through books and publications. His subject matter was similar to that of French Symbolism, with its emphasis on the less sun-lit areas of history and myth, but he brought to it a satirical and cruel eye. Where the French painters often seemed to take their subjects too seriously, Beardsley would always be careful to let his public know that his attitude was, in a sense, a pose. This enabled him to relate his work to contemporary mores and avoid the remoteness of much of the work of the Salon de la Rose + Croix. Perhaps only Félicien Rops, on the Continent, brought a similarily jaundiced flavour to Symbolism.

But both the Arts and Crafts Movement round Morris, and the Aesthetic Movement round Beardsley, looked to the past for their sources. A new idea was needed, something that would not be dependent on eclecticism. And when the idea came, it manifested itself in the most unlikely of countries: Scotland.

Charles Rennie Mackintosh was a native of Glasgow and his most important work was done in that city. As one might expect, the English totally ignored his work. It was left to the Austrians to take up his ideas and disseminate them through Europe. His main claim to fame is as an architect, and is therefore outside the scope of this book, but his ideas and methods had an effect on all the arts. Mackintosh introduced the idea that design should be something that sprang naturally from function, rather than being an arbitrarily imposed cosmetic. This meant that he designed buildings from the inside out, letting the form grow naturally from the function, and where he needed a style of design, for details and decoration, he turned to the most natural of styles: the organic.

Organic structures were not new to art. Much 'primitive' art reflects the patterns of natural growth, and a case can be made for considering Gothic in these terms. Since the Renaissance, however, art had largely been seen in terms of subject matter and representational style, and it was not until the turn of this century that artists again looked at the natural patterns of organic growth.

What they found was a method of working that solved the problems of 'style' that had beset the Symbolists. Instead of thinking of an idea and then finding a suitable style in which to express it, artists and designers could apply the organic style to literally anything. It was a radical idea and appropriately called Art Nouveau.

41 The glass doors for the Willow Tea Rooms in Glasgow are a good example of Mackintosh's style. They lead into a room entirely designed by the artist, so there is a unity to the whole conception. The doors are reminiscent of Celtic art, which also drew on plant forms, and like Celtic art they are abstract. Instead of representing something through an image, they function entirely in terms of colour, light and line, and the sheer beauty of the design is enough to

create the mood desired. Certain motifs appear which are typical of Mackintosh: the stylized rose form and the long stem-like rods of metal. Clients entering the 'Room de luxe' through these doors could feel that they were becoming part of an aesthetic experience that in no way interfered with the business of taking tea.

The decorative ease of Mackintosh's work must have seemed a great relief after the gloomy exoticism of the Symbolists, and very quickly the style spread to Vienna where it influenced the Secession group, and then to Holland which was itself already evolving an Art Nouveau style. In Vienna, Mackintosh's use of pure pattern influenced the painter Gustav Klimt who combined fairly straightforward figures with areas of almost abstract pattern. In *The Kiss* it is the robe of the man that is the subject of the painting, and the psychological element is nearly absent, while in *Danaë* the awkward placing of the nude makes us read the picture as a flat pattern. The face of the girl still has that look of erotic self-absorption so beloved of the Symbolists, but it is almost incidental to the impact of the patterns. We tend to read the painting as a flat surface pierced by shallow depressions, two dimensions juxtaposed with three.

As one might suspect from the appearance of Klimt's work, he saw himself primarily as a mural painter. The flat quality of the Art Nouveau style is particularly applicable to decorative schemes, but more difficult to apply to the easel painting. In fact there are very few Art Nouveau paintings as such; the vast body of work in the style is applied to decorative schemes or functional objects.

In Holland, however, painters did apply themselves to the problems of the Art Nouveau painting. Dutch artists evolved a style independently of the French and Austrian schools, and may even have influenced Mackintosh. They combined the subject matter of Symbolism, which was sacramental and mystical,

47

46

with the flat arabesques of Art Nouveau. Bonding this mixture was the influence of Java, at that time a part of Holland's empire, and one can easily detect the use of Javanese stick puppets in the work of Jan Toorop.

Toorop had been brought up in Java; and, whereas the exoticism of French Symbolism is usually obviously borrowed, Toorop's was inherent in his background. His masterpiece, *The Three Brides*, is a genuinely disturbing painting because it is so un-European; although its subject is very much in the Western tradition, its style and philosophy are not.

The painting shows three aspects of woman at the same ceremonial moment of marriage. On the right is the Bride as courtesan, on the left the Bride of Christ, and in the middle the 'human' Bride. But the two Brides at each side are not necessarily meant to be read as Good and Evil, the standard Western interpretation of such dualities; if one reverses the painting and looks at it from the inside out, then the figure at the left hand of the Human Bride can be seen as representing the Left Hand Path of Tantric Hinduism, and that on the right the Right Hand Path. The Left Hand Path was usually associated with the goddess Kali, who like the figure in Toorop's painting is conventionally shown wearing a necklace of skulls. She represents not evil but achievement through eroticism and a close knowledge of the links between birth and death. The Right Hand Path is the path of meditation and of transcending the body. Tantric thought does not say that one path is better than another. Toorop has tried to show the nature of the difference between them, both in his treatment of the figures and in the background. The patterns in the air above the Kali figure are strong and decisive; those above the Bride of Christ are fluid and natural in form. The figure in the centre represents the middle way, but, because it is a product of the two poles of experience rather than something that exists in its own right, it is veiled.

Similar imagery can be found in paintings by the other well known Dutch painter of the time, Johan

49 Thorn Prikker. His painting of *The Bride* shows a similar use of flat linear design, but it is less hieratic and *faux-naïf* in execution. Thorn Prikker was influenced by French painting and particularly by the Pont-Aven school around Gauguin. His forms are given more body than Toorop's, and the brushwork is more 'painterly'. The result is an almost abstract style held together by strong curving lines. The imagery is more overtly Christian than Toorop's and does not attempt to draw the philosophical lines of distinction that appear in *The Three Brides*.

But Art Nouveau is at its purest and is most successful when applied to a purpose other than the easel painting. It was a style that lent itself very well to graphic reproduction because areas of flat colour are the essence of lithographic technique. And, as posters are functional by their very nature, Art Nouveau artists found themselves designing advertisements.

It is this aspect of the movement, more than any other, that characterizes Art Nouveau as being the first movement of the twentieth century rather than the last of the nineteenth. One of the central issues of modern art has been the erosion of the idea that art is something separate from life. Art now takes place in the streets as well as the art gallery, and the first manifestation of this idea was the advertisement. Toorop felt no difficulty designing an advertisement

50 for salad oil, because he was allowed a free hand. He was able to experiment with subtle combinations of colours and a linear style, and the result is both a beautiful work of art and a sophisticated piece of sales promotion. And it is indicative of the degree to which Art Nouveau styles had penetrated normal life that the manufacturers should have considered this type of advertisement useful.

Although Toorop's sources were Javanese, the art of the poster looked primarily to Japan for inspira-

tion. The Japanese print had become widely fashionable in the second half of the century, and had influenced almost all artists working at the time. From the work of Hokusai and Hiroshige, European artists learnt how to organize a flat surface, distorting perspective where necessary and balancing areas of flat colour with line. Henri de Toulouse-Lautrec

58 shows the influence very clearly in his *Divan Japonais* poster with its curiously steep perspective.

Posters became the principal Art Nouveau medium in all the countries of the Western world, and each country evolved its own style. French posters often show the lingering influence of Symbolism; the

51 figures in Alphonse Mucha's posters still show traces of that country's obsession with the idea of Woman the Temptress. And perhaps because of the country's long history of painting, artists there found it more difficult to adapt to the discipline of lithographic techniques. Neither Mucha nor Georges de

53 Feure uses the flatness of lithography as much as their Austrian or Dutch counterparts; they still tend to draw in three dimensions, and so their graphic work is more complicated than other contemporary work.

57 The Dutch designers, led by Henry van de Velde, specialized in very linear, frequently abstract, designs with much emphasis on lettering. They were particularly skilful at juxtaposing colour to produce a slight vibration. The influence of this type of design spread to Germany and can be seen in Bernhard

52 Pankok's exquisite design for the 1900 World's Fair catalogue. Colour and form have been released from any descriptive role, and the artist is free to achieve pure abstract beauty.

In Germany the style was called 'Jugendstil', after

55 the magazine *Jugend* ('youth'), and was split between those who, like Pankok, were influenced by the delicate abstract style of the Dutch, and those who leant towards the more robust style of the Vienna

54 Secession. Sattler's *Pan* is typical of the latter style,

with its deliberate imagery and use of blocks of rich colour.

59 In England, the Beggarstaff Brothers (William Nicholson and James Pryde) evolved a style that left large areas of the picture bare of any ink, a trick they learned from Toulouse-Lautrec and Bonnard, and the style even reached America with the work of William

60 Bradley who adapted it to the flavour of that country.

 Art Nouveau never produced a school of sculptors as such; but in applying the ideas of Art Nouveau to

56 objects, designers were able to retain the idea of function while investigating sculptural possibilities. The art of Emile Gallé was restricted to the making of vases, usually of polychrome glass, but it is really the true sculpture of Art Nouveau. In Nancy he inspired a school of designers and glass-workers whose work is often almost indistinguishable from his own. Typical

61 of the Nancy style is the tulip-like vase illustrated here; formal aspects are kept to the minimum, enhancing the effect of the meticulously considered surface, with its mother-of-pearl iridescence. The influence of Japanese ceramics is evident in the maker's willingness to let accident play a part in the design, juxtaposing rich glaze effects with simple shapes.

 The same cannot be said for Louis Comfort

62 Tiffany, the other great maker of glassware of the period. Where Gallé was designing for a few French connoisseurs, Tiffany's clients were rich Americans who came to his shop in New York to buy decorations for their town apartments. His work is altogether more flamboyant, and the iridescent effects used more openly. Tiffany never achieved the purity of the Nancy style, but his immensely popular work has, at its best, a ponderous beauty.

 Jewellery also proved an excellent medium for Art Nouveau and produced one master of the art. This

63 was Lalique, who worked principally with silver, baroque pearls and semi-precious stones. The regularity of cut stones such as diamonds or rubies did not

appeal to him, but with stones such as moonstone and opal he made luminous pieces of great delicacy using stylized representations of animals and plants.

Being such a widely based movement, Art Nouveau was susceptible to changes in fashion. Unlike many art movements, which seem to be jealously guarded secrets, Art Nouveau found its public almost immediately. It was good form in fashionable circles to have your vases by Gallé, as it had been in Britain to have wallpaper by Morris. And being a fashion, the style changed, so when Serge Diaghilev arrived in town with his Ballets Russes, the linear aspect of Art Nouveau was put to the service of Oriental exoticism. And because it was so firmly based in society, Art Nouveau disappeared with the destruction of the old ways in 1914.

After sleeping for fifty years, Symbolism and Art Nouveau are back with us. Gallé vases fetch even higher prices than they did in 1900, and Morris wallpapers are seen everywhere. Even the more ridiculous Symbolist paintings are breaking records in the salerooms, and no doubt many more 'minor masters' will be discovered to fill gaps in the supply to the market. How to react to these exotic blooms, every man must decide for himself, but it is certain that without Symbolism's heady attempt on the citadel of Mystery, and without Art Nouveau's wilful decorative elegance, the history of art would be safer but duller territory.

Further Reading

Because Symbolism has only recently resurfaced, there are few general books on the subject. The movement's principal apologist is Philippe Jullian, whose *Dreamers of Decadence* (London and New York, 1971) and *The Symbolists* (London and New York, 1974) are general surveys of French Symbolism with particular attention paid to the Salon de la Rose + Croix. Jullian's approach is uncritical but in both works he illustrates many paintings that will not be found elsewhere. Edward Lucie-Smith in *Symbolist Art* (London and New York, 1972) takes a wider and more critical viewpoint. The catalogue of the 1972 Arts Council of Great Britain exhibition 'French Symbolist Painters' contains a great deal of documentary information on the movement. The peculiar flavour of Paris in the last two decades of the nineteenth century is best described in J. K. Huysmans, *A rebours* (English translation, *Against Nature*, Harmondsworth and New York, 1958.)

The influence and theories of Gauguin are discussed in detail by Wladyslawa Jaworska in her *Gauguin and the Pont-Aven School* (London and Greenwich, Conn., 1972); and the aesthetic background to the Gauguin circle is the subject of H. R. Rookmaakers' difficult but rewarding *Synthetist Art Theories* (Amsterdam 1959). Most of these books have extensive bibliographies.

Art Nouveau has been fashionable for longer, and there are many small books about the movement, of which the best is Renato Barilli's *Art Nouveau* (London and New York, 1969). *Art Nouveau* (London and New York, 1962), by Robert Schmutzler, and *The Age of Art Nouveau* (London and New York, 1966), by Maurice Rheims, are both exhaustive surveys of the field; and there is a good introduction to William Morris and his circle in *The Arts and Crafts Movement*, by G. Naylor (London, 1971).

Chronology

1848–50 England: Pre-Raphaelite Brotherhood formed. Rossetti paints *Ecce Ancilla Domini*.

1874 France: First Impressionist exhibition.

1876 France: Moreau exhibits *Salome*.

1879 France: Redon's lithographs first published.

1881 France: Puvis exhibits *The Poor Fisherman*.

1883 England: Arts and Crafts Exhibition Society formed.

1884 France: Huysmans publishes *A rebours*.

1886 France: Gauguin's first visit to Brittany.

1888 France: Gauguin paints *Vision after the Sermon*. Nabis founded.

1889 France: Gallé exhibits vases in Paris World Exhibition. Gauguin sees exhibit about French colonies in the South Seas.

Norway: Munch paints *The Cry*.

1891 France: Gauguin leaves for Tahiti.

1892 France: Salon de la Rose + Croix formed.

1893 USA: Tiffany begins to design vases.

Holland: Toorop paints *The Three Brides*.

1894 England: Beardsley illustrates *The Yellow Book*.

1895 Germany: First publication of *Pan*.

1896 Germany: First publication of *Die Jugend*.

1897 Austria: Vienna Secession formed.

France: Last exhibition of Salon de la Rose + Croix.

1898 France: Moreau and Puvis die.

1903 Marquesas Islands: Gauguin dies.

1904 Scotland: Willow Tea Rooms designed by Mackintosh.

1916 France: Redon dies.

List of Illustrations

Measurements are given in inches and centimetres, height first.

1 Paul Gauguin (1848–1903). *Vision after the Sermon (Jacob Wrestling with the Angel)*, 1888. Oil on canvas, $28\frac{3}{4} \times 36\frac{1}{4}$ (73 × 92). National Gallery of Scotland, Edinburgh. See p. 10.

2 Emile Bernard (1868–1941). *Breton Women on a Wall*, 1892. Oil on canvas, $31\frac{7}{8} \times 45\frac{3}{4}$ (81 × 116). Collection M. and Mme Samuel Josefowitz, Lausanne. See p. 16.

3 Maurice Denis (1870–1943). *Breton Dance*, 1891. Oil on canvas, $16\frac{1}{8} \times 13$ (41 × 33). Collection M. and Mme Samuel Josefowitz, Lausanne. See p. 18.

4 Paul Gauguin (1848–1903). *Self-portrait: Les Misérables*, 1888. Oil on canvas, $17\frac{3}{4} \times 21\frac{5}{8}$ (45 × 55), Vincent van Gogh Foundation, Amsterdam. See p. 17.

5 Paul Sérusier (1864–1927). *Landscape: the Bois d'Amour (The Talisman)*, 1888. Oil on canvas, $10\frac{5}{8} \times 8\frac{1}{4}$ (27 × 21). Private collection. See p. 19.

6 Eugène Grasset (1841–1917). *Spring*, 1884. Stained-glass window, $115\frac{3}{4} \times 52$ (294 × 132). Musée des Arts décoratifs, Paris. See p. 20.

7 Charles Filiger (1863–1928). *Breton Cow-herd*. Gouache, $15\frac{1}{2} \times 6\frac{1}{2}$ (28 × 23). Collection M. and Mme Samuel Josefowitz, Lausanne. See p. 19.

8 Maurice Denis (1870–1943). *April*, 1892. Oil on canvas, $14\frac{3}{4} \times 24$ (37.5 × 61). Rijksmuseum Kröller-Müller, Otterlo. See pp. 20, 26.

9 Lucien Lévy-Dhurmer (1865–1953). *Marsh Birds in a Landscape*, 1910–14. Oil on canvas (panel), $80\frac{1}{8} \times 114$ (206 × 290). Metropolitan Museum of Art, New York (Harris Brisbane Dick Fund 1966). See p. 21.

10 Lucien Lévy-Dhurmer (1865–1953). *Our Lady of Penmarc'h*, 1896. Oil on canvas, $16\frac{1}{8} \times 13$ (41 × 33). Private collection. See p. 20.

11 Paul Gauguin (1848–1903). *Where do we come from? What are we? Where are we going?*, 1897. Oil on canvas, $55\frac{1}{2} \times 148\frac{1}{4}$

(139 × 375). Museum of Fine Arts, Boston (Arthur Gordon Tompkins Residuary Fund). See pp. 22, 43.

12 Paul Gauguin (1848–1903). *Spirit of the Dead Watching (Manao Tupapau)*, 1892. Oil on canvas, $28\frac{3}{4} \times 36\frac{1}{4}$ (73 × 92). Private collection. See p. 21.

13 Pierre Puvis de Chavannes (1824–98). *The Poor Fisherman*, 1881. Oil on canvas, $61 \times 75\frac{3}{4}$ (155 × 192). Louvre, Paris. See p. 25.

14 Pierre Puvis de Chavannes (1824–98). *St Genevieve Watching over Paris*, 1886. Oil on canvas (wall panel). Panthéon, Paris. See p. 25.

15 Ferdinand Hodler (1853–1918). *The Mönch*, 1911. Oil on canvas, $25\frac{3}{8} \times 36$ (64.5 × 91.5). Private collection. See p. 26.

16 Gustave Moreau (1826–98). *Hercules and the Hydra of Lerna*, c. 1870. Watercolour on paper, $9\frac{7}{8} \times 7\frac{7}{8}$ (25 × 20). Musée Gustave Moreau, Paris. See p. 27.

17 Gustave Moreau (1826–98). *Salome Dancing before Herod (Tattooed Salome)*, detail, 1876. Oil on canvas, $36 \times 23\frac{5}{8}$ (92 × 60). Musée Gustave Moreau, Paris. See p. 28.

18 Gustave Moreau (1826–98). *Voice of Evening*. Watercolour on paper, $13\frac{3}{8} \times 8\frac{5}{8}$ (34 × 22). Musée Gustave Moreau, Paris. See p. 29.

19 Odilon Redon (1840–1916). *Portrait of Gauguin*, 1904. Oil on canvas, $26 \times 21\frac{5}{8}$ (66 × 55). Louvre (Jeu de Paume), Paris. See p. 32.

20 Odilon Redon (1840–1916). *Pandora*, c. 1910. Oil on canvas, $56\frac{3}{4} \times 24\frac{3}{8}$ (144 × 62). Metropolitan Museum of Art, New York (Bequest of Alexander M. Bing, 1959). See p. 30.

21 Arnold Böcklin (1827–1901). *Isle of the Dead*, 1886. Oil on panel, $31\frac{1}{2} \times 57\frac{1}{2}$ (80 × 150). Museum der bildenden Künste, Leipzig. See p 34.

22 Alexandre Séon (1857–1917). *The Chimaera's Despair*, 1890. Oil on canvas, $25\frac{1}{2} \times 20\frac{1}{8}$ (65 × 53). Private collection. See p. 38.

23 Léon Frédéric (1856–1940). *The Lake—The Sleeping Water*, 1897–98. Oil on canvas, $80\frac{3}{4} \times 50$ (205 × 127). Musées Royaux des Beaux-Arts, Brussels. See p. 38.

24 Jean Delville (1867–1953). *Satan's Treasures*, 1895. Oil on canvas, 141 × 145 (358 × 368). Musées Royaux des Beaux-Arts, Brussels. See p. 35.

25 Armand Point (1860–1932). *The Siren*, 1897. Oil on canvas, 35½ × 27¾ (90 × 70). Private collection, Switzerland. See p. 38.

26 Carlos Schwabe (1866–1926). *Death and the Gravedigger*, 1895–1900. Watercolour and gouache, 29½ × 22 (76 × 56). Louvre (Cabinet des Dessins), Paris. See p. 39.

27 Edvard Munch (1863–1944). *The Scream*, 1893. Oil on cardboard, 35⅞ × 29 (91 × 73.5). Nasjonalgaleriet, Oslo. See p. 41.

28 Edvard Munch (1863–1944). *Madonna*, 1895–1902. Lithograph, 35⅞ × 17½ (60.7 × 44.3). Nasjonalgaleriet, Oslo. See p. 42.

29 Auguste Rodin (1840–1917). *Fugit Amor*, 1885–87. Marble, 22½ × 43⅜ × 15¾ (57 × 110 × 40). Musée Rodin, Paris. See p. 43.

30 Medardo Rosso (1858–1928). *Ecce puer*, 1906. Bronze, h. 18⅛ (46). Galleria d'Arte Moderna di Ca' Pesaro, Venice. See p. 43.

31 James Ensor (1860–1949). *Self-portrait with Masks*, 1899. Oil on canvas, 46½ × 32 (118 × 83). Collection Mme C. Jussiant, Antwerp. See p. 40.

32 Pablo Picasso (1881–1973). *Woman Ironing*, 1904. Oil on canvas, 44½ × 28⅜ (115 × 72). Private collection. See p. 43.

33 Augusto Giacometti (1877–1947). *Night*, 1903. Tempera on canvas, 98 × 43⅜ (251 × 110). Kunsthaus, Zurich. See p. 44.

34 Giovanni Segantini (1858–99). *The Love Goddess*, 1894–97. Oil on canvas, 82¾ × 56¾ (210 × 144). Galleria Civica d'Arte, Milan. See p. 43.

35 Carlos Schwabe (1866–1926). *The Virgin of the Lilies*, 1899. Watercolour, 38¼ × 18½ (97 × 47). Private collection. See p. 39.

36 Dante Gabriel Rossetti (1828–82). *Ecce Ancilla Domini (The Annunciation)*, 1850. Oil on canvas mounted on wood, 28½ × 16½ (72 × 42). Tate Gallery, London. See p. 45.

37 Sir Edward Coley Burne-Jones (1833–98). *The Golden Stairs*, 1880. Oil on canvas, 109 × 46 (276 × 117). Tate Gallery, London. See p. 48.

38 Sir Edward Coley Burne-Jones (1833–98). *The Prince Enters the Briar Wood* from 'The Briar Rose' Series 1, 1870–90. Oil on canvas, 48 × 98 (122 × 247.8). The Faringdon Collection Trust, Buscot Park, Faringdon, Berkshire. See p. 48.

39 Sir Edward Coley Burne-Jones (1833–98). *The Sleeping Beauty* from 'The Briar Rose' Series 4, 1870–90. Oil on canvas, 48 × 90 (122 × 227.5). The Faringdon Collection Trust, Buscot Park, Faringdon, Berkshire. See p. 48.

40 Charles Annesley Voysey (1857–1941). *Tulip and Bird* wallpaper, 1896. Victoria and Albert Museum, London. See p. 49.

41 Charles Rennie Mackintosh (1868–1928). Door to the 'Room de luxe' of the Willow Tea-Rooms, 1904. Painted wood, metal, and coloured glass, each panel $77\frac{1}{8} \times 27\frac{1}{8}$ (196 × 69). The House of Frazer, Glasgow. See p. 51.

42 Aubrey Beardsley (1872–98). *Isolde*, c. 1895. Colour lithograph, $9\frac{3}{4} \times 5\frac{7}{8}$ (24.8 × 15). See p. 50.

43 Arthur Heygate Mackmurdo (1852–1942). Textile design, 1884. William Morris Gallery, London. See p. 49.

44 William Morris (1834–96). *Daffodil* chintz, 1891. See p. 49.

45 William de Morgan (1839–1917). Twin-handled amphora in Persian colouring, 1888–97. H. $13\frac{1}{2}$ (34.3). See p. 49.

46 Gustav Klimt (1862–1918) *Danaë*, 1907–08. Oil on canvas, $30\frac{1}{2} \times 32\frac{3}{4}$ (77 × 83). Private collection. See p. 52.

47 Gustav Klimt (1862–1918). *The Kiss*, 1909. Watercolour and gouache, paper on wood, $75\frac{5}{8} \times 46\frac{3}{8}$ (192 × 118). Musée des Beaux-Arts, Strasbourg. See p. 52.

48 Jan Toorop (1858–1928). *The Three Brides*, 1893. Coloured drawing, $30\frac{3}{4} \times 38\frac{5}{8}$ (78 × 98). Rijksmuseum Kröller-Müller, Otterlo. See p. 53.

49 Johan Thorn Prikker (1868–1932). *The Bride*, 1892–93. Oil on canvas, $57\frac{1}{2} \times 33\frac{7}{8}$ (146 × 88). Rijksmuseum Kröller-Müller, Otterlo. See p. 54.

50 Jan Toorop (1858–1928). *Delftsche Slaolie*, before 1897. Colour-lithographed poster, 39 × 27 (99 × 70.2). See p. 54.

51 Alphonse Mucha (1860–1930). *Gismonda*, 1894. Poster. See p. 55.

52 Bernhard Pankok (1872–1943). Endpaper design for the catalogue of German Empire exhibit at the Paris World's Fair, 1900. Colour lithograph, $9\frac{1}{2} \times 7\frac{1}{2}$ (24.2 × 19). See p. 55.

53 Georges de Feure (1868–1928). *Le Journal des ventes*, 1897. Poster. See p. 55.

54 Josef Sattler (1867–1931). *Pan*, 1895. Poster. See p. 55.

55 Ludwig von Zumbusch (1861–1927). Cover for *Jugend* (No. 40), 1897. See p. 55.

56 René Wiener (1856–1939). Portfolio for engravings, 1894. Inlaid leather. Musée de l'Ecole de Nancy, Nancy. See p. 56.

57 Henry van de Velde (1863–1957). *Tropon*, 1898. Colour-lithographed poster, $14\frac{1}{8} \times 11\frac{3}{4}$ (36 × 29.9). See p. 55.

58 Henri de Toulouse-Lautrec (1864–1901). *Divan Japonais*, 1893. Poster, $31\frac{1}{4} \times 23\frac{3}{8}$ (79.5 × 59.5). See p. 55.

59 Beggarstaff Brothers (William Nicholson, 1872–1949, and James Pryde, 1866–1941). *Girl on a Sofa*, 1895. Poster. See p. 56.

60 William Bradley (1868–1962). *The Chap Book*, 1894. Poster. See p. 56.

61 Daum (d. 1909), after Bussière (?Ernest Bussière, d. 1937). Glass vase, *c*. 1900. Museum für Kunst und Gewerbe, Hamburg. See p. 56.

62 Louis Comfort Tiffany (1848–1933). Glass vase, *c*. 1900. See p. 56.

63 René Lalique (1860–1945). Decorated cup. Österreichisches Museum für angewandte Kunst, Vienna. See p. 56.

COVER
Sir Edward Burne-Jones (1833–98). *The Beguiling of Merlin* (detail), 1874. Oil on canvas, $73 \times 43\frac{1}{2}$ (185.5 × 110.5). Courtesy of the Trustees of the Lady Lever Art Gallery, Port Sunlight.

1

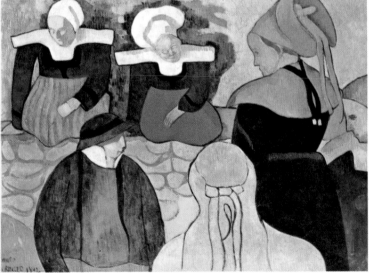

2

3

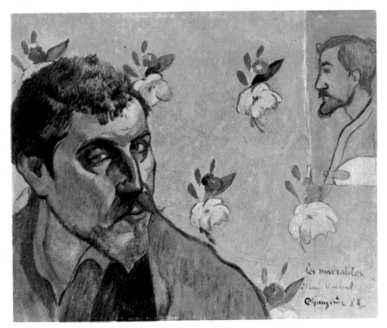

4

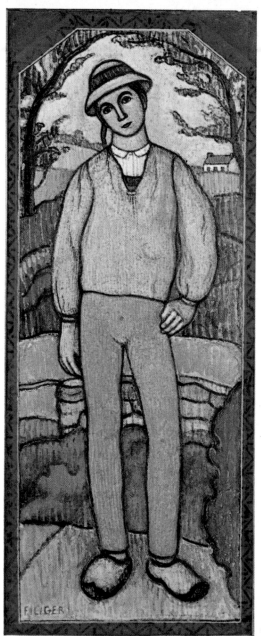

7

9

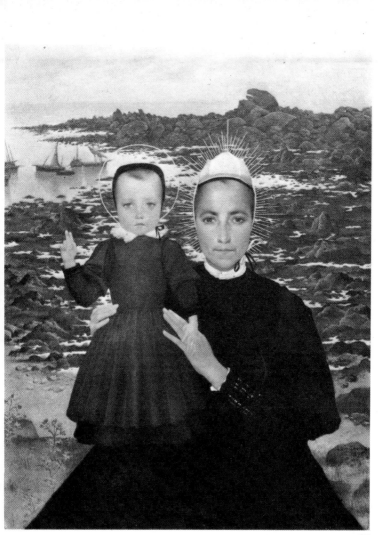

10

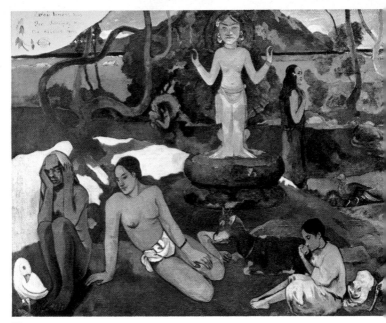

11

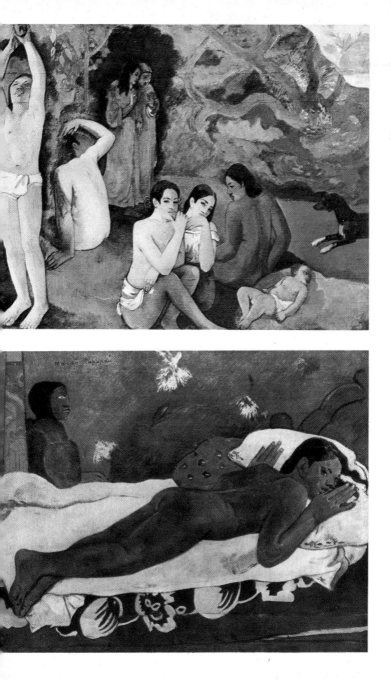

13

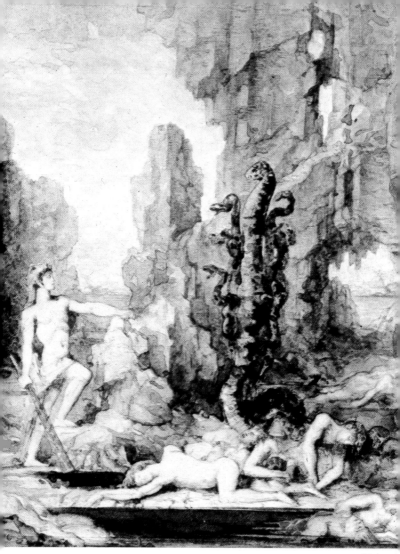

16

17-18 ▶

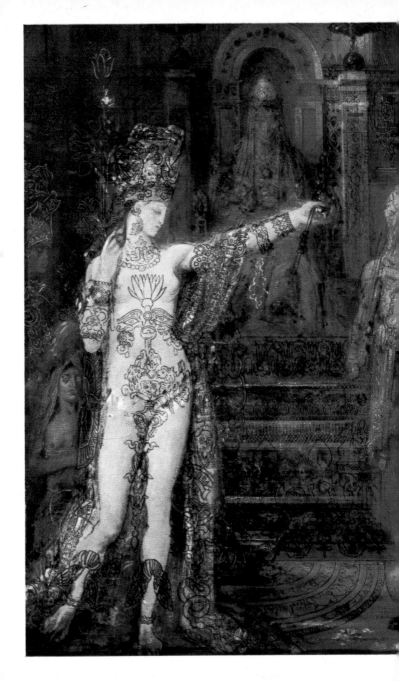

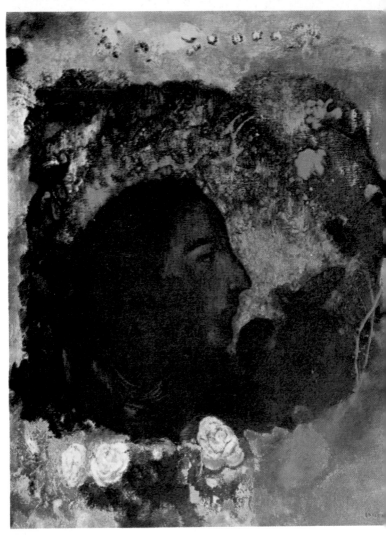

19

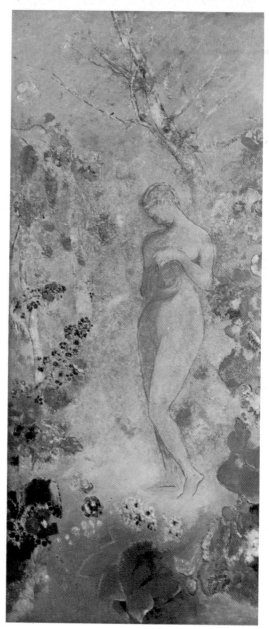

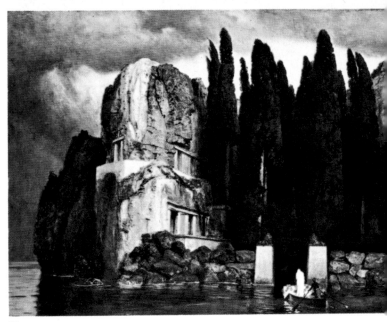

21

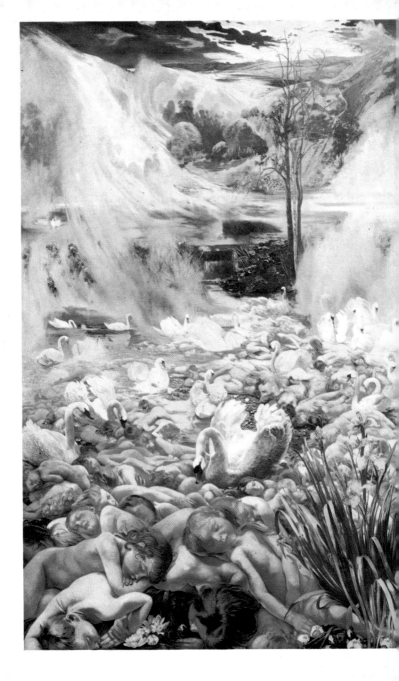

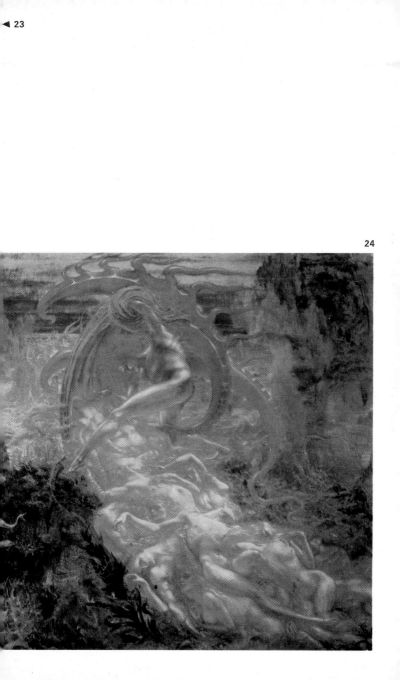

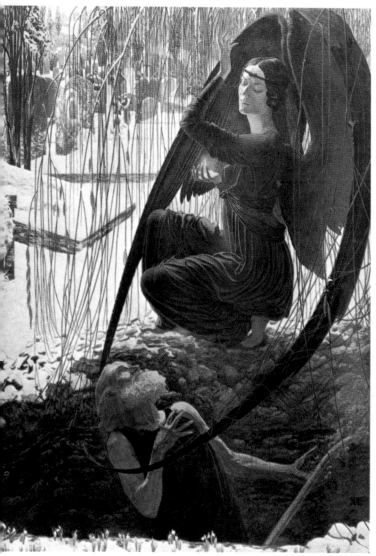

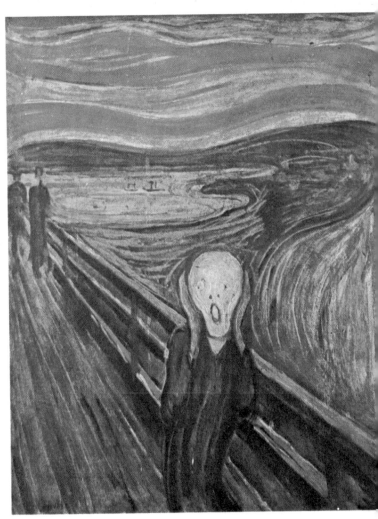

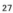

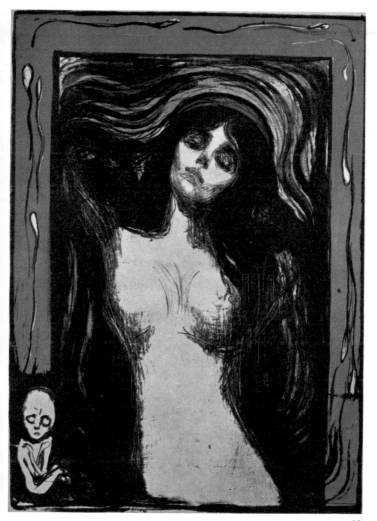

28

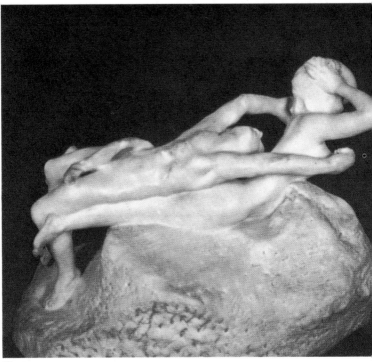

29

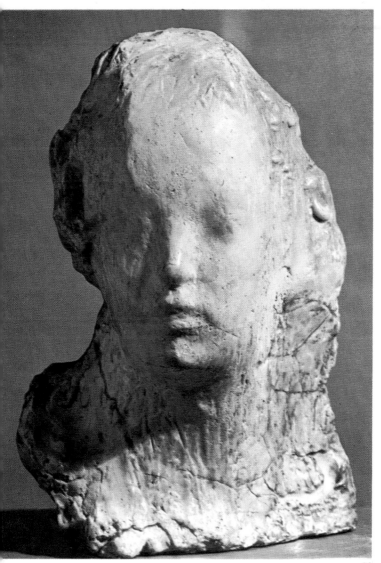

30

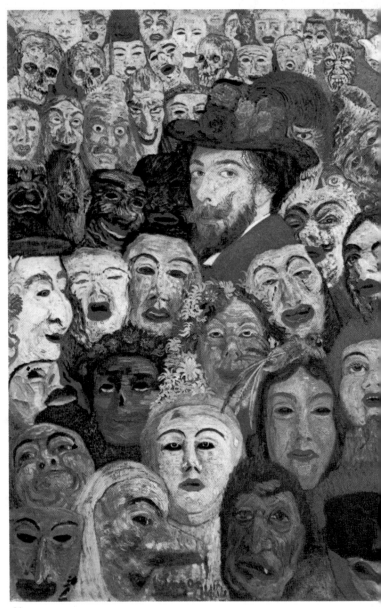

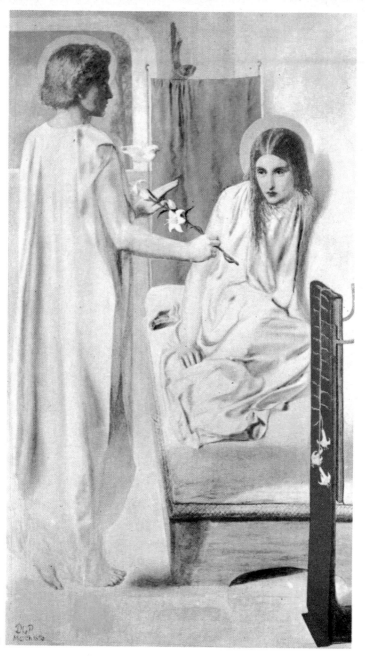

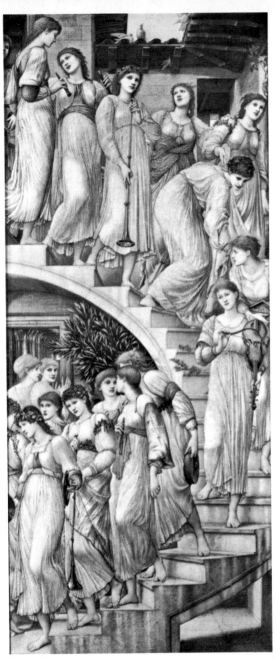

37

41

ISOLDE

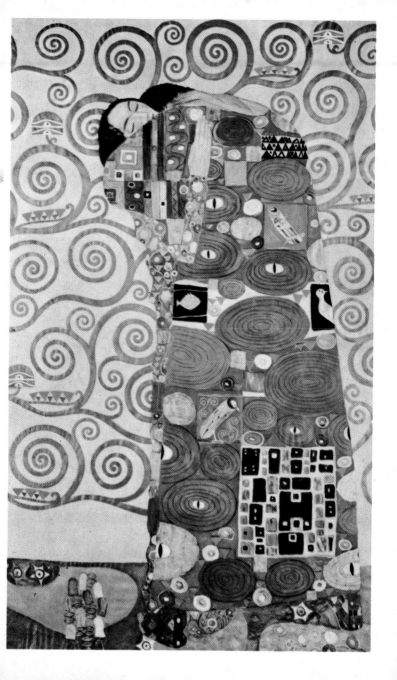

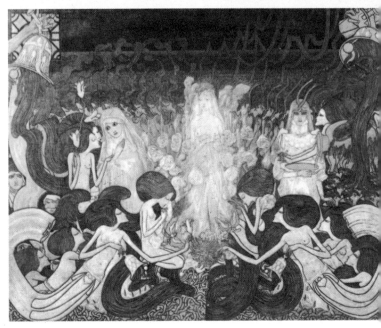

48

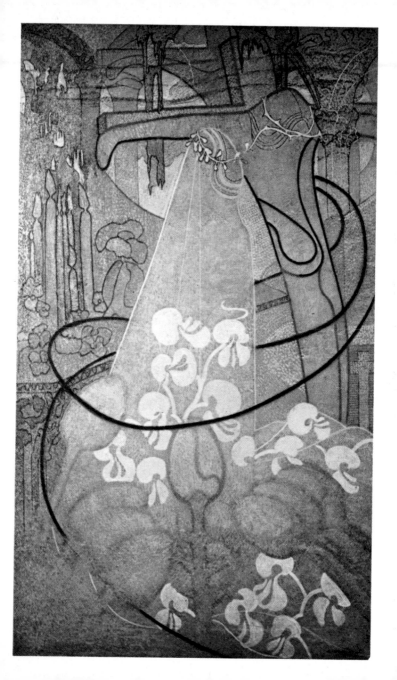

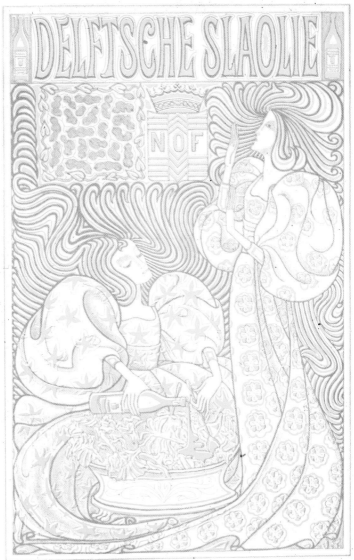

DELFTSCHE SLAOLIE

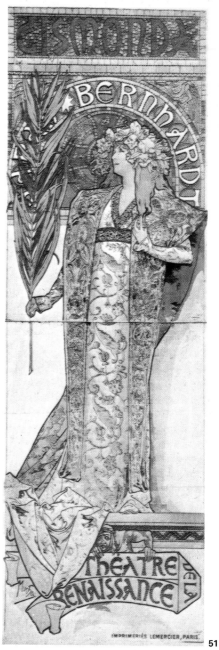

52

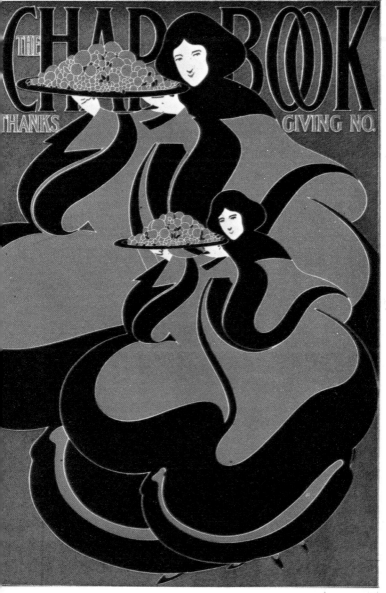

THE CHAP BOOK
THANKS GIVING NO.

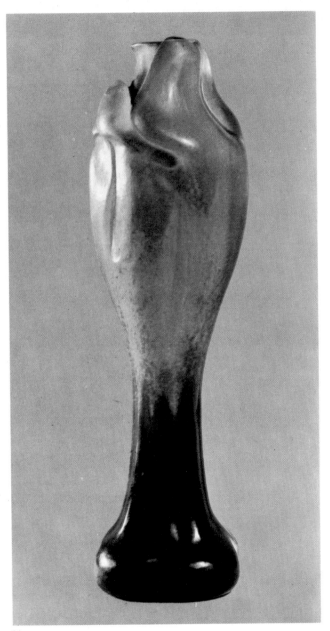

61

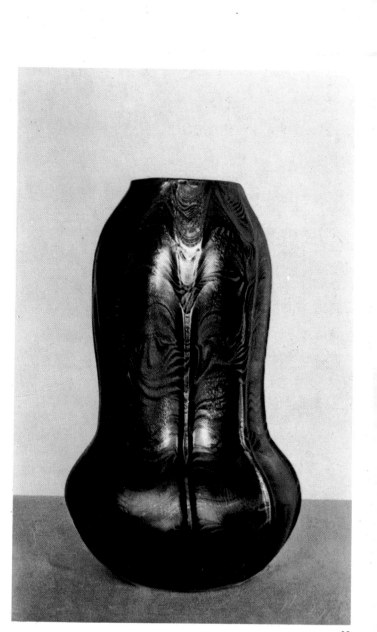

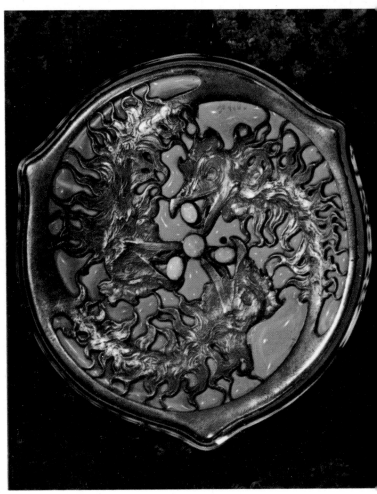